A Shaker Family Album

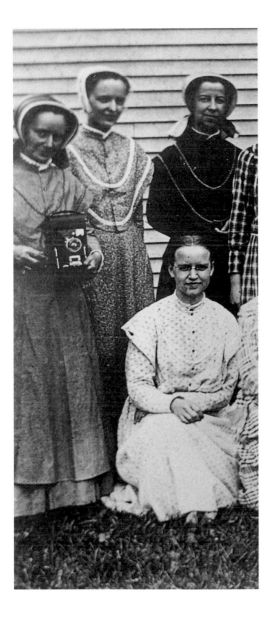

A Shaker Family Album

Photographs from the Collection of
Canterbury Shaker Village

David R. Starbuck and Scott T. Swank

UNIVERSITY PRESS OF NEW ENGLAND Hanover and London

University Press of New England, Hanover, NH 03755
© 1998 by University Press of New England
All rights reserved
Printed in Singapore 5 4 3 2 1
CIP data appear at the end of the book

Contents

Foreword

✳ The Shakers in and around Canterbury, New Hampshire, were "called to order" by the Central Ministry in New Lebanon, New York, in 1792. That same year the Canterbury believers erected a Meeting House and began to develop their lands. Shakers occupied the village continuously from that date through 1992, when the last Shaker, Sister Ethel Hudson, died at the age of ninety-six. The village is now a historic site museum owned and administered by a nonprofit educational organization, Canterbury Shaker Village, Inc.

Serious study of the history of the Canterbury Shakers began in the 1970s with a Boston University project led by Dr. David Starbuck. Starbuck's archaeological survey and mapping of Canterbury Shaker Village is significant for several reasons. First, it established the fact that the large tract of Shaker land in Canterbury is one of the most pristine historical sites in New England. Second, the work discovered and described a dimension of Shaker life that has been relatively unappreciated to date, namely their skill and ingenuity as social and civil engineers in building an elaborate network of mills and waterways on land far removed from a major river. Third, Starbuck thoroughly documented for posterity what he and his students and colleagues found, thus converting history into a useful planning tool for Canterbury Shaker Village as a nonprofit educational institution.

The importance of Starbuck's work has been readily apparent as Canterbury Shaker Village entered its third century of existence in 1992, the Bicentennial year of the Shaker call to order in Canterbury. With the deaths of Eldress Gertrude Soule in 1988, Eldress Bertha Lindsay in 1990, and Sister Ethel Hudson in 1992, the Canterbury Shaker community ceased to exist.

The village as a museum requires energetic leadership, clear vision, and massive resources in order to preserve the best of the past and realize the potential of the future. The village could have no better planning tool than the base line documentation provided by Starbuck.

Starbuck's modern scholarship has been complemented by additional documentation provided by the Shakers themselves. Open to the advances of nineteenth-century technology, the Canterbury Shakers selectively welcomed outside photographers into their community, and then embraced photography for their own purposes. The result is a disproportionately large body of documentary photography for a relatively small New England community. These photographs, combined with the discoveries of archaeological study, provide essential guides to the material and personal lives of the family of Shakers who called Canterbury "home."

The village in 1993 placed its 694 acres of former Shaker land under permanent conservation easement and entered into partnership with its neighbors to protect from development most of the original Shaker tract in Canterbury. The village is aggressively pursuing a program of architectural conservation to preserve the National Landmark site for future generations. The 1990s have been an era of expanded public service as the village seeks to fulfill its potential as an educational institution. Although its mission is not to promote Shaker religion, the village seeks to accurately portray Shaker values in historical context and in a contemporary museum setting. Although no Shakers remain at Canterbury, the village will operate for public benefit in the belief that the Shaker gift of life is still unfolding. The invitation for the public at Canterbury is to enter into an active dialogue between past and present rather than passively visit a foreign past.

March 1997

Scott T. Swank

Preface

� When I first visited Canterbury Shaker Village in February of 1977, I was a professor at Boston University, and I was making preparations for a project that would record the history, archaeology, architecture, and landscape of an amazingly well-preserved Shaker community. Unlike the many Shaker villages that had closed, Canterbury had survived with most of its landscape and twenty-four of its buildings intact. More importantly, it was still the home of three very committed Shakers who were determined that the values of Shakerism be passed on to future generations. For Eldress Bertha Lindsay (1897–1990), Eldress Gertrude Soule (1895–1988) and Sister Ethel Hudson (1897–1992), it was a time of rapid change as Canterbury underwent the transformation from a cloistered, communal society into a museum village that saw ever-greater numbers of visitors come to admire what Shaker believers had taken two hundred years to create.

For my students from Boston University and, later, the University of New Hampshire, Canterbury became an exciting laboratory in which to study, interview, prepare measured drawings, and conduct archival research. I worked with teams of students at Canterbury Shaker Village during the summers of 1978, 1979, and 1980, and our research was funded by a series of matching grants from the National Park Service through the New Hampshire Division of Historical Resources/State Historic Preservation Office. Because our work was being conducted in a relaxed setting that put us in daily contact with the Shakers, these were pleasant and productive years that enabled us to prepare historic structure reports for nearly all of the buildings still standing in Canterbury, contour maps of the surrounding Shaker-modified landscape, and inventories of many of the historical docu-

ments stored at the village. While most of my students and other paid consultants completed their studies in 1980, my own association with Canterbury has continued to the present, and it is just as pleasant to visit there today as it was twenty years ago.

It was during the summer of 1978 that we discovered the rich collection of historical photographs stored at the village. One of our graduate students from Boston University, Patricia O'Neil, was promptly put in charge of inventorying these images, some of which were stored in the safe in the Brethren's Shop office and the rest in Eldress Bertha Lindsay's dresser drawers in the Trustees' Office. It quickly became clear that there were far too many photographs to be quickly studied during a single summer, and over the next several years I prepared captions, rephotographed most of the images, and arranged for local photographic studios to reprint many of the photographs on archivally stable paper. Fortunately, Bertha Lindsay had been a consummate photographer when she was younger and had taken many of the images herself. Her recollections of the people and places in some of the photographs helped in the process of identifying the images. Also of great assistance were the captions other Shakers had written on the backs of photographs and underneath some of the prints that had been mounted into photographic albums.

In more recent years, additional historical photographs have been donated to Canterbury Shaker Village, and the total archive of images now numbers in the many thousands. They include stereographs from the 1860s and 1870s, formal studio portraits from the late 1800s, and postcards from the 1910s, 1920s, and later. The vast majority, though, are snapshots taken by the Shakers themselves with Brownies and Eastman Kodaks between about 1910 and 1930. The quality varies greatly. Some are not in focus, others have faded over the years, and still others were handled too many times by curious visitors to the village. But, taken as a whole, this photographic collection provides an excellent glimpse into late-nineteenth- and twentieth

century life inside one of the most fascinating communal societies in the world.

The Canterbury Shakers photographed many aspects of life in their community, and the vast majority of images were clearly not intended to be seen by the "world's people." The stereographs and postcards were distributed by the thousands and were meant to introduce the outside world to Shaker society and to generate much-needed revenue. But the thousands of snapshots from the 1910s, 1920s, and 1930s were clearly meant to be enjoyed among small groups of friends within the Shaker community. It is these snapshots that are most abundantly represented within this volume and that have prompted the title, *A Shaker Family Album*. Most have never been published before, and they provide a friendly, inside look at the Shakers which is truly "through Shaker eyes."

It has been difficult selecting one hundred fifty images out of a corpus of many thousands, and no doubt other photographs will eventually be found that are technically superior to some of the ones printed here. However, the intention has been to select photographs that are especially revealing of the day-to-day lives of the Canterbury Shakers, and consequently images have been selected and grouped according to central aspects of Shaker life. The introductory essays and accompanying images provide a behind-the-scenes look at Shaker life that will be very new for most readers and reveals the warmth and gentleness of this very special people.

While working with the Canterbury photographs, I have been helped by a great many scholars and staff at Canterbury Shaker Village, and I especially wish to thank Scott Swank, President, and the Board of Trustees of Shaker Village, Inc., for providing access to their photographic archives and for allowing the reproduction of some of Canterbury's best photographs within this volume. I also wish to thank Charles ("Bud"), Nancy, and Darryl Thompson for much assistance in identifying photographs over the years; Julia Fifield and Howard Moffett for their encouragement in finish-

ing this book; and Linda Ray Wilson for first introducing me to the Shakers in Canterbury. And most of all, I wish to thank the last Canterbury Shakers—Eldress Bertha, Eldress Gertrude, and Sister Ethel—for their many years of support, kindness, and wisdom which prompted the preparation of this volume.

The original captions for the pictures—written by Shakers and their friends in albums or on the backs of the photographs have been retained and are set within quotation marks. Punctuation and capitalization that has been added or changed appears within square brackets. Dates are given when these are known. At the end of each modern caption, the current location or catalog number is included as a finder's guide. All images are in the archives at Canterbury Shaker Village unless otherwise noted.

March 1997 *David R. Starbuck*

A Shaker Family Album

Introduction

DAVID R. STARBUCK

The Shakers

✺ "The United Society of Believers in Christ's Second Appearing," better known as the Shakers, was founded in Manchester, England, in the mid-eighteenth century by James and Jane Wardley. The movement was then taken to America in 1774 by its early prophetess, "Mother Ann" Lee, and grew to encompass some nineteen villages in the eastern United States. As a religion that never had more than five or six thousand members at a time, and that today has just a handful of adherents at only one village, Sabbathday Lake in Maine, Shakerism has given rise to a truly amazing wealth of religious writings, sacred music and dance, craft manufactures, and furniture.

From eighteenth-century England until today, Shakerism has been a Christian communal society whose distinctively dressed members believe in the sharing of property, pacifism, celibacy, and the equality of men and women. They do not vote or bear arms but are obedient to the Millennial Laws of the Shaker Society. In the absence of sex and marriage, new members necessarily arrived from among "the world's people" and converted; but many others were orphans who had been placed with the Shakers as children and later chose to join when they reached maturity. At their peak, Shaker communities provided peaceful environments in pleasant rural settings, but each village rarely had more than a few hundred members at a time. It was explicitly recognized that the Shaker way of life was not for everyone. The first Shaker village in America, founded by Mother Ann in Niskeyuna, New York, never had more than about three hundred fifty

members, and even the home of the Lead Ministry—the community of New Lebanon, New York—never grew beyond about six hundred members before the final members departed in 1947.

Shakerism is often viewed as a response to the difficulties of the industrial revolution of the nineteenth century, and as a phenomenon that did not outlast that era. While it is true that membership was in serious decline after 1850, the Shaker faith has shown itself to be remarkably resilient and long-lasting. Also, Shakerism has never been a static faith, nor has Shaker thought been monolithic—there have been both progressive and traditionalist camps. Twentieth century Shakerism continues to have its own distinctive character, and the Shakers of the past one hundred years have adopted much from the outside world—including automobiles, televisions, and modern kitchen appliances—and their recent history is generally well understood because it has been recorded so thoroughly in journals, church records, photographs, interviews, and television documentaries.

Canterbury Shaker Village

Only a handful of Shaker communities survived into the twentieth century, but one of these—Canterbury Shaker Village—saw its influence steadily increase even as membership declined at other larger and more powerful villages. Located in central New Hampshire about twelve miles north of Concord, Canterbury first experienced the millennial zeal of the Shakers when missionaries Israel Chauncey and Ebenezer Cooley preached in the adjacent town of Loudon in 1782. A Canterbury farmer, Benjamin Whitcher, heard their message, invited local believers to join him in communal living on his hundred-acre farm, and formally called to order—or "gathered"—a Shaker community in February of 1792.

When the first Shakers arrived in Canterbury, they were presented with

an irregular landscape that included some of the flattest farm land for miles around (where the North Barn Field is today), dropping off to swamps a thousand feet to the east. There were small streams, including Meadow Brook to the west, but in general this was a rocky landscape without any large bodies of water or easy sources of waterpower. Benjamin Whitcher had built his farm at the southern end of the most level fields, and when he donated his land and buildings to the Shaker Society, the Church Family was raised around his farm buildings. When later clusters of buildings—the Second and North Families—were laid out to the north, they too were positioned on the flattest land. Each family thus stretched out along "Shaker Road," the principal north-south axis through the community. From this high overlook, with a commanding view to the south and east, the main road went south to Loudon and Concord and north to the town of Belmont.

The Canterbury Shakers created a landscape that was very much their own; they cleared stones from the fields and built stone walls, dams, and ponds; the land was cultivated, orchards were planted, and hundreds of acres were used to graze cattle and sheep. For much of the nineteenth and twentieth centuries, most of the Shaker lands in Canterbury were practically denuded of trees, presenting open vistas broken only by small clusters of buildings and fruit trees. Even today, stone walls continue to be in evidence practically everywhere, composed of stones taken from the fields and laid up to form partitions along the sides of the fields. The very substantial stone walls lining the sides of Shaker Road were laid in 1797 and 1798 and saw periodic rebuilding. When coupled with the granite walkways that link each of the buildings, the overall effect is clearly one of order and symmetry.

In 1792, as Whitcher's family farm was transformed into a Shaker village, the construction of new buildings better suited to a communal life style began immediately. A Meeting House for worship was erected under the

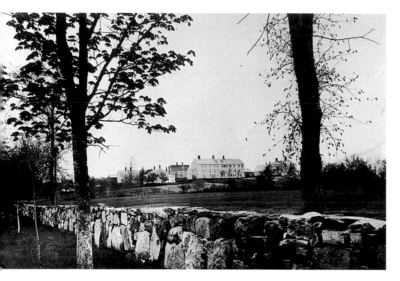

Figure 1 "North family—from the south." [Album 46]

supervision of Moses Johnson in the summer of 1792, and a large Dwelling House followed in 1793. As needs dictated and resources permitted, the community added numerous workshops, group residences, and farm buildings, along with a School House (1823) and a Trustees' Office (1830–1832), which handled business dealings with the outside world. Agriculture became a central part of the community's economic base, and, in all directions, the Canterbury Shakers developed and managed hay fields, pastures, orchards, and wood lots. However, there were naturally occurring streams and marshes along the eastern side of the village, and beginning in 1800 the Shakers dug channels and dammed up marshes to create a highly efficient mill system of eight artificial ponds and eighteen mill buildings, all linked by ditching.[1] A smaller mill system was also built on the west side of the village, along Meadow Brook. The village eventually swelled to encompass about three thousand acres, and for most of its history, Canterbury Shaker Village was able to achieve a high degree of autonomy in its manufactures, as well as in its food production.

Over the space of two hundred years, four large Shaker "Families" were formed in Canterbury to meet the housing needs of novitiates and more senior members. The earliest of these was the Church Family, sited where Whitcher's farm had once stood, home of the ruling ministry and those who were most senior in their faith. Running north along Shaker Road, a Second (or Middle) Family—for those who had never been married—was added in 1800. Next, a North Family for novitiates (probationary members) was established in 1801. And, located just a half-mile west of the North Family, a West Family was briefly in existence between 1806 and 1818. Each Family was led by its own elders and eldresses, although the only church and school were located at the Church Family. All together, the Canterbury Shakers constructed over one hundred dwellings, craft shops, and farm buildings, only twenty-six of which still stand today—twenty-four at the Church Family, one at the Second, and one at the North.

The Shakers constructed a cemetery on the west side of Shaker Road,

just north of the Church Family, and Elder Henry Blinn planted an arboretum in the Church Family in 1885–1886, containing trees representative of every native species in New Hampshire. Maple trees were set out along the sides of Shaker Road in 1855 and 1871, and other maples were placed along the lane leading up to the Meeting House in 1859 and 1860. The maple trees were planted by youngsters in order to beautify the village, but deliberate plantings also included several orchards of apple, pear, and peach trees that were integral to the community's economy. The Church Family planted an apple orchard in the North Orchard Field in 1795, with peach trees on its western edge; an orchard called "Paradise" was planted west of the Trustees' Office; and the last Church Family apple orchard—which still stands—was planted in 1917 in Meeting House Field. The North Family also had a "Peach Orchard" (that included apple trees) just east of North Family Pond.

Because Mother Ann passed away in 1784, she never had the opportunity to visit the Canterbury village, but beginning with a core of forty-three converts, the community grew to a peak of 233 members in 1843.[2] Among their many accomplishments, the Canterbury Shakers were justifiably famed for their successful farming practices and introduced Durham and Guernsey cattle and Berkshire pigs to central New Hampshire. They continued to maintain prize-winning herds of Guernseys and Holsteins as recently as 1920, at which time they sold their herds. Butter was produced for sale in the Church Family Creamery, vegetable seeds were packaged and sold, apples and pears were raised in extensive orchards, and a large grove of sugar maples allowed the Shakers to sell great quantities of maple sugar products each year. But just as impressive was the manufacture of baskets, sweaters, washing machines, brooms, wooden pails, sewing boxes, patent medicines, and a host of other goods. Notably, Canterbury became the principal publishing center for the Shaker faith in 1882 and also is remembered for having produced more music than any other Shaker society.

Shaker life in Canterbury thus appears to have been comfortable—and

creative—and the community earned an enviable reputation for its seed industry, its cattle and orchards, its print shop, its music, its school, and its manufactures. Perhaps most famous among the latter was the Dorothy Shaker Cloak of the late nineteenth century, named after its creator, Eldress Dorothy Durgin (1825–1898). But work was not the only focus of Canterbury life, and increasingly time was devoted to worship, to recreation, to trips to other Shaker villages, and to excursions to Lake Winnisquam and coastal beaches. The importance of leisure activities within Shaker society is perhaps the most neglected aspect of Shaker studies, and nothing exemplifies this better than the great pleasure the Canterbury Shakers derived from the theatricals they produced, chiefly between 1895 and 1921. Calling them "entertainments," the Shakers loved putting on plays in the Chapel of the Church Family Dwelling House, especially at Christmas, Easter, and on Washington's Birthday. While many of these were Biblical in nature, there were secular performances too.

Although Canterbury was certainly one of the most long-lived and successful of the Shaker villages, after the Civil War there was a long period of decline. New members continued to join the Canterbury community, but a great many of the children who were left with the Shakers chose to return to the outside world, and there were just ninety-seven members in the year 1899.[3] Later, when the State of New Hampshire created its own orphanages, this virtually ended the Shakers' principal source of new members.

The North Family closed in 1894—although the buildings were still standing in 1905[4]—and the buildings of the Second Family were subsequently removed in 1915–1916. The last Shaker brother, Irving Greenwood, died in 1939, and even many of the buildings of the still-functioning Church Family were removed in the 1940s and 1950s to save money on taxes and maintenance. But after all, fewer craft shops, farm buildings, and dwellings were needed to house the rapidly shrinking population. In 1957 the community saw a growth in its importance when the Lead Ministry of the entire Shaker Society moved to Canterbury. But in 1965, a few years af-

ter the death of Elder Delmer Wilson, the last male Shaker in Maine, the Lead Ministry voted to close membership in the Society. With no prospect for future members, the Canterbury Shakers began to plan for the day when there would be no Shakers left at their beloved community.

By 1970 there were only six elderly Shakers living in Canterbury, and the first steps had been taken to create a museum village. The only new arrival after that date was Eldress Gertrude Soule of Sabbathday Lake, who moved to Canterbury in 1972 and stayed until her death in 1988. A nonprofit educational corporation, Shaker Village, Inc., was formed in 1969 to preserve the Shaker legacy in Canterbury. Guided by the wishes of the remaining Shakers, Canterbury began to hire professional museum staff, developed exhibits, and started the ongoing process of public interpretation. The opening up of their village to the public unquestionably gave the Canterbury Shakers a direction and a mission during their final years, a chance to share the basic tenets of their faith with all who would listen.

The last Shaker eldresses, Bertha Lindsay and Gertrude Soule, did much to shape this period of transition, ensuring that Shaker beliefs and values would not be lost as a museum was formed. Ultimately, the passing of Sister Ethel Hudson in 1992 marked the end of two centuries of continuous Shaker occupation in Canterbury, but by no means the end of telling the Shaker story. While much remains to be done, today over 65,000 visitors from throughout the world tour the Church Family buildings at Canterbury Shaker Village each year, and Shaker beliefs and manufactures continue to reach a very receptive audience.

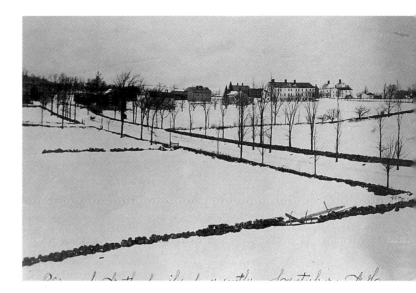

Figure 2 "North Family. Taken down in the 1920s." [P218]

Canterbury Shaker Photographers and Cameras

Beginning in the late nineteenth century, photography was an extremely popular hobby for the Canterbury Shakers, who first allowed professional photography studios to capture them on film and later took many thou-

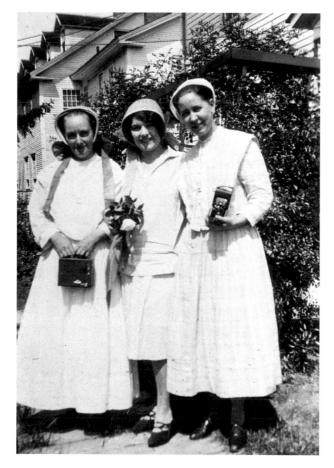

Figure 3 "Lillian, Clara, Evelyn." Sisters Lillian Phelps (left) and Evelyn Polsey (right) are both holding Eastman Kodak cameras in front of the Church Family Dwelling House. Sister Evelyn was born in Pawtucket, Rhode Island, in 1891 and entered the Canterbury Society in 1902. One of her principal tasks was to serve as head cook in the Dwelling House kitchen. [No album no.]

sands of photographs of each other, their village, and their work and play activities. The archives of Canterbury Shaker Village contain between ten and twelve thousand of these images (including many duplicates), constituting a major body of primary data that will be invaluable to all future interpretation of the community. They may, in fact, be the most thorough photographic record of twentieth-century life that exists for any Shaker village.

The subjects of these photographs include early portraits of Shakers that were taken by professional photographic studios; buildings (both standing and destroyed); mills and millponds; the Shakers at work in their fields and within their workshops; winter activities such as sledding and making snowmen; farm machinery, automobiles, trucks, and boats; horses, cows, dogs, and cats; group portraits, sometimes used to recruit new members; picnics and visits to the beach; musical groups; floats in parades; and theatrical "entertainments" with Shaker performers. Some of the more formal photographs may perhaps reinforce the popular impression of the Shakers as an overly serious, hard-working society, but the unsmiling, posed portraits are greatly outnumbered by recreational scenes of Shakers playing and relaxing.

Significantly, certain Shaker activities or settings consistently went unrecorded. For example, indoor photographs were rare before the 1940s because of poor lighting, but at that time Sister Bertha Lindsay obtained a large reflecting light that enabled her to take photographs indoors.[5] And nearly all photographs portray locales within the Canterbury Church Family, no doubt because the Second, North, and West Families had closed before cameras were widely used in the village. In fact, before 1900 the Canterbury Shakers did not take their own pictures, and professional photographers did not commonly go to the village. Instead, the Shakers went to the Kimball Studio in Concord, New Hampshire, when they wanted to have their portraits taken.[6]

Because few Shaker brothers lived into the twentieth century, another area that is poorly represented in photographs is the entire realm of male-oriented activities, except for the occasional appearance of hired men in agricultural scenes. While the hired men were clearly non-Shakers, their role within the community was a critical one in the late 1800s and early 1900s because nearly all activities were defined as explicitly "male" or "female." Without the hired men, farm and mill work would have come to an early end. But rarest of all are photographs of religious services, and among the few that have survived in Canterbury are ones that were deliberately posed for a *Life* Magazine article that appeared on March 21, 1949.[7]

Over eleven hundred historical negatives have survived in Canterbury, as well as many hundreds of postcards and nearly six hundred stereographs. The stereograph cards were prepared in the 1860s and 1870s and depict Shaker buildings, landscape views, people, animals, and crafts. They were first produced by William H. and Joseph L. Kimball of Kimball Studio in Concord, and later by William's sons, Willis G. C. and Howard A. Kimball. Coming later in time, the postcards are perhaps even more informative because they all show aspects of the Shakers which they *chose* to share with the outside world, and no doubt some of the postcards may have been designed with the recruitment of new members in mind. Before 1900, stereograph cards were something that visitors could take home with them, and after 1900, they were replaced by Shaker postcards that were commercially produced, often from photographs the Shakers had taken themselves. These were merchandised to the world's people who increasingly visited the village, thanks to the popularity of tourism and automobiles. The postcards usually show the exteriors of well-kept Shaker buildings, as well as a few interiors and panoramas, and they are extremely effective in showcasing the latest technological acquisitions at the village. It was not until the Depression that postcards dropped off in popularity, although the telephone also contributed to their demise.

The Canterbury Shakers preserved many of their photographs in albums, and quite a few of these were labeled with the date, the activity, or the names of the subjects. Predictably, quality is uneven because some images are out of focus, some have been handled too frequently over the years, and some were printed from extremely small negatives taken with poor quality cameras. Until very recently, these albums were stored in the Brethrens' Shop at the village and in Bertha Lindsay's own personal collection. Since then, many were copied onto microfilm in 1985 at the Northeast Document Conservation Center, and all have been placed into archival storage.

The invention of inexpensive, hand-held cameras helped photography become a favorite national pastime in the early twentieth century, and most existing Canterbury photographs date from this period. By the 1920s, a great many of the Shakers who resided in Canterbury were taking pictures, and this was done first with "Brownie" cameras and later with Eastman Kodaks. Usually the Shakers would buy cameras in large lots, to get a better price, and several of the Canterbury Shaker sisters developed their pictures in a darkroom they had constructed in the Children's House of the Church Family. Those who processed their own pictures included Sisters Evelyn Polsey, Eunice Clark, Gertrude Roberts, and Edith Green. Others sent their negatives to be processed at Dunlap Photo in Concord and, eventually, all processing was done in Concord because it was cheaper.[8] Only Brother Irving Greenwood owned a large-format camera that required glass plate negatives. This was an "Ideal" camera, manufactured by Rochester Optical Co. (Rochester, N.Y.), and it used a Bausch & Lomb lens (Pat. Jan. 6, 1891).

According to Eldress Bertha Lindsay, all of those mentioned above were busily taking photographs in the early twentieth century, as were Sisters Blanche Gardner, Alice Howland, Lillian Phelps, and Josephine Wilson.[9] In 1922 Eldress Bertha received her own first camera, an Eastman Kodak, and she continued to be one of the most avid Shaker photographers up until the 1960s, when her eyesight failed. She never developed any of the nega-

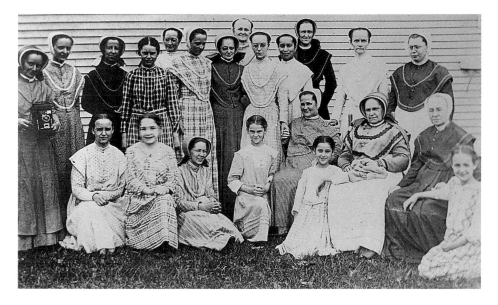

Figure 4 In this large group portrait of Canterbury sisters and girls, Sister Lillian Phelps (*left*) is holding an Eastman Kodak camera. Sister Lillian was born in East Boston, Massachusetts, in 1876 and arrived in Canterbury in 1892. Her tasks as a Shaker included making sweaters and items for sale in the gift shop, and she worked as a cook in the Dwelling House kitchen. The Shakers typically bought several cameras at a time to economize, and sisters often took turns photographing the same scene. [11-P151]

tives herself, but most of her prints are still stored in the archives at Canterbury Shaker Village.

There is no question that the Canterbury Shakers often wanted to document their own history in a systematic fashion, and sometimes this took the form of photographing a building throughout its construction, or recording the various stages in producing a craft item, or documenting the installation of a new drain system throughout the village. But as often as not, photography was simply a hobby that enabled the Shakers to record their friends, their surroundings, and the visitors who had come to see them. The wide range of themes in the photographs is convincing proof that the Canterbury Shakers were a hard-working but fun-loving people, filled with enthusiasm for their way of life and engaged in nearly all of the same activities as the world's people. While their religious beliefs required that they be physically separate from the outside world, Canterbury Shaker photography suggests that life inside the sect really was not all that different.

It is undeniable that the Shakers were superb at marketing images of themselves, usually of somber brothers in broad-brimmed blue hats and

prim sisters in their bonnets, and there is no evidence that they wished to provide outsiders with a more relaxed image of themselves. The twentieth-century photographs of the Canterbury Shakers were not intended to be shared with non-Shakers, and that is precisely where their value lies—they reveal to us a world in which the Shakers are more at ease than we might otherwise expect. Given the care and discretion with which the Canterbury Shakers presented themselves to the world, we can only hope that *A Shaker Family Album* contains images that would have been acceptable to the Shakers had they made the selections themselves.

NOTES

1. David R. Starbuck, "The Shaker Mills in Canterbury, New Hampshire," *IA: The Journal of the Society for Industrial Archeology* 12, 1 (1986), pp. 11–38.

2. Demographic figures for the Shakers in Canterbury are summarized, by year, in Richard C. Borges, "The Canterbury Shakers: A Demographic Study," unpublished Ph.D. dissertation, Dept. of History, University of New Hampshire, Durham, 1988.

3. Ibid.

4. Eldress Bertha Lindsay, transcript of tape recording no. 1, 1978, p. 12.

5. Eldress Bertha Lindsay, personal communication.

6. Ibid.

7. *Life* Magazine, March 21, 1947. Two photographs show sisters seated inside the Chapel in the Dwelling House.

8. Eldress Bertha Lindsay, personal communication.

9. Eldress Bertha Lindsay, personal communication, April 12, 1982.

Stereographs

✳ The invention of photography presented a challenge to the Canterbury Shaker leadership. But, based on photographic evidence, the Shakers embraced photography as an opportunity, not a threat. Always progressive technologically, the Shakers in all communities eagerly experimented with the new medium, and Shaker leaders began to use photography to their advantage to present their image to a curious world.

The official portrait photographers of the Canterbury Shakers were William H. and Joseph L. Kimball of Concord, New Hampshire, and most of the portraits of the early Shakers were taken in the Kimball Studio, established in 1849 on State Street. William's son, Willis G. C. Kimball, would subsequently become the premier stereograph photographer in Concord from the late 1860s through the 1880s. As such, he was the ideal person to produce a series of views of the Canterbury Shaker Village for the Shakers, their visiting public and the curious everywhere. Whether Kimball or the Shakers first proposed such a series is not known, but other Shaker villages were doing their own series of stereographs, so there was no Shaker opposition to the concept. For Kimball, a Shaker series of views offered the type of exotic public appeal that stereographs were designed to capture.

At least 350 different views are known for the nineteen Shaker villages, and Willis G. C. Kimball advertised 58 different views in the Canterbury series. Kimball could not have taken his "views" without permission from the Shakers, but perhaps the Canterbury Shakers saw an opportunity to turn public curiosity to their benefit. The Kimball stereograph views can thus be seen as part of an overall strategy to change the world's image of Shakers. The Kimball views include the Shakers' Sugar Camp, natural

phenomena, winter views, buildings, and the Shakers themselves. Kimball's stereographs are more oriented toward the general concept of "community" than toward Shakerism as a religion, and the image they create is one of prosperity and success within a beautiful and ordered community.

The photographs reveal the natural beauty of Canterbury's hilltop location and the sublime beauty of the mill ponds. In addition to well-fed cattle and pastoral agricultural scenes, the views contain numerous pictures of the Shakers as an industrious community deliberately pursuing the economic well-being of the entire settlement. None of the harshness of industrialization marks life at Canterbury, and the stereographs show a village in which everyone seems to be contributing and benefiting in an atmosphere of beauty, friendliness, and mutual cooperation. Through the years of organization, growth, and the establishment of discipline, Shakerism had achieved a reputation for being strange, mysterious, and harsh. Against this background, the Shaker stereographic views can be seen as a deliberate attempt by the Canterbury leadership to soften their image, dispel the mystery, and remove the stigma of eccentricity.

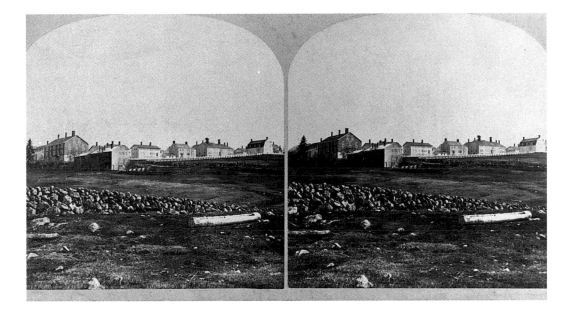

Figure 5 "No. 2. Church Family from the South." The Church Family is sited where Benjamin Whitcher's 100-acre farm once stood. It became the core of the Canterbury Society when the "gathering" formally established Canterbury as a Shaker Village in 1792. As the other Canterbury Families declined and closed, their members joined those at the Church Family. Stereograph produced by H. A. Kimball, ca. 1867. [S104]

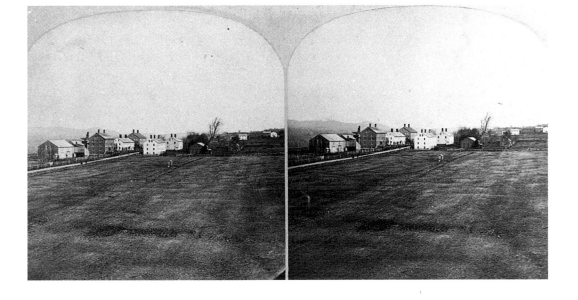

Figure 6 "Second Family" or "Middle Family." While located only a short distance north of the Church Family, the Second Family became home to those who had never been married but for some reason had not yet qualified for full membership. Established as a covenantal order in 1800, this later became a branch of the Church Family in 1871 and then home to members of the newly closed North Family in 1894. Stereograph produced by H. A. Kimball, ca. 1867. [Canterbury Shaker Village Archives, S120, from the collection of Henry C. Blinn]

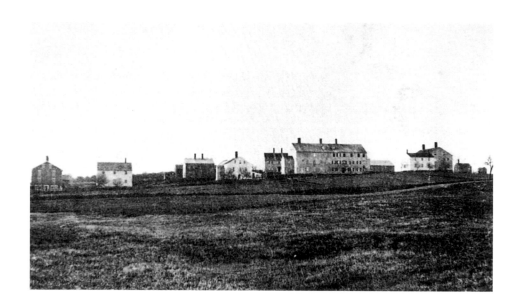

Figure 7 "No. 5. North Family." The North or "Novitiate" Family was located north of the Second Family and was composed of previously married men and women who had joined the Canterbury community with their families but had not yet fully subscribed to the Shaker way of life. Formed in 1801 as a way to initiate new converts into the community, resident elders and eldresses instructed the probationary members until they were deemed ready to become Shakers. However, this Family experienced a slow decline as new converts dropped off. The last seven brothers and twenty-two sisters moved to the Second Family, and everything was torn down except for the brick North Family Trustees' Office. Stereograph produced by H. A. Kimball, ca. 1867. [S121]

Figure 8 "No. 4. Church Family from the North." The Church Family Cow Barn, completed in 1858, was the center of dairying operations at the village, and virtually all of the Shaker barns were maintained in immaculate condition. The trees in this view were laid out along Shaker Road in the 1860s. Stereograph produced by H. A. Kimball, ca. 1867. [S106]

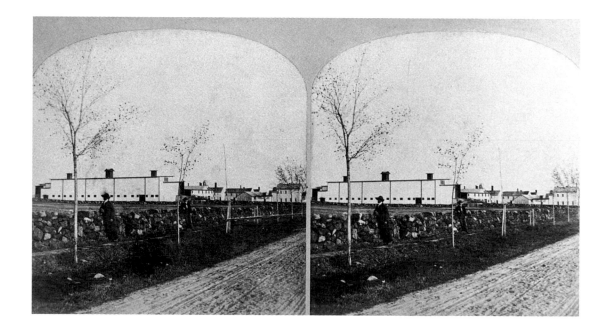

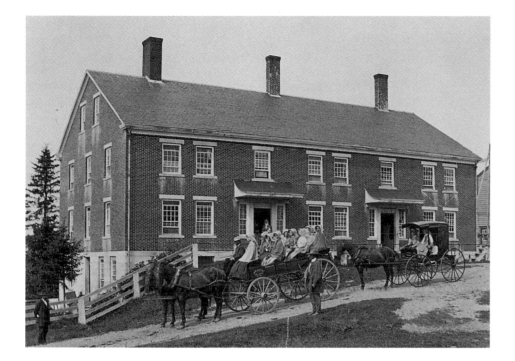

Figure 9 "No. 20. Trustees' Office." The Church Family Office building, made of pressed bricks manufactured by the Shakers, was constructed between 1830 and 1832. It was the third office built for the Trustees, who managed the Shakers' business dealings with the outside world. It was also the first building in the community to have a roof of slate (rather than shingles). It became a U.S. Post Office in October of 1848, with Trustee David Parker as its first postmaster, and continued to be the Shakers' post office until 1938. Stereograph produced by William Kimball, ca. 1872–1878. [S111]

Figure 10 "No. 56. View during Divine Service." The Church Family's Meeting House Lane is occupied by numerous carriages of the world's people, lined up during a Sunday morning worship service. The building of the three-story Church Family Meeting House was supervised by Shaker master builder Moses Johnson in 1792, and it was the sixth of eleven Shaker Meeting Houses that he designed and constructed. The front (west) facade has double entrances, left for brothers and right for sisters. Stereograph produced by W. G. C. Kimball, ca. 1878. [S17]

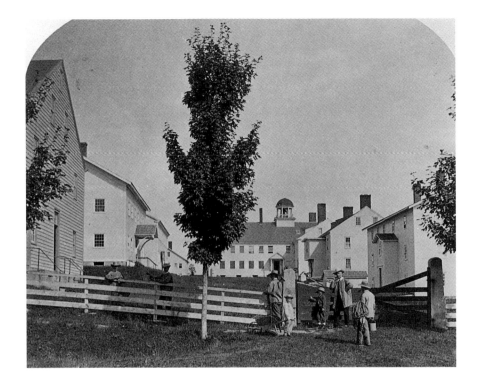

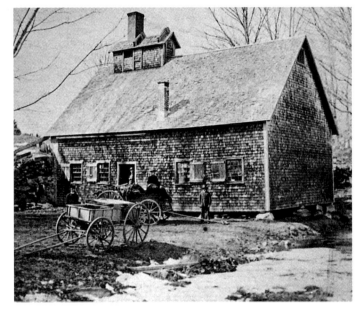

Figure 11 "No. 4. Church Family, from the west." Several Shaker brothers and boys stand at one of the gates that leads into the interior of the Church Family. Most of these buildings still stand, although the central building on the right was replaced by the Enfield House in 1918. Stereograph produced by W .G. C. Kimball, ca. 1878. [S11]

Figure 12 "No. 33. South View of the Camp." The Shakers' sugar camp and an extensive grove of over 1,000 sugar maples were located southeast of the Church Family. This permitted the Canterbury sisters to produce thousands of pounds of maple products each year. Stereograph produced by W. G. C. Kimball, ca. 1878. [S129]

Postcards

✳ Throughout the second half of the nineteenth century, visitation by tourists increased steadily at Canterbury Shaker Village. Many repeat visitors were friends of the Shakers, who stopped to pay their respects during summer months. Institutions such as St. Paul's School in Concord, a private Episcopal boarding school for boys, brought students each winter for a tour and Shaker dinner. The majority, however, were first-time tourists, and so the Canterbury Shakers became unintentional participants in the rapidly expanding vacation industry of New Hampshire.

One example of the direct link between summer visitors and the Shakers can be seen in the number of group tours sponsored by the resort hotels of the Lakes Region. With the arrival of the railroad and the ending of the Civil War, central New Hampshire was able to attract sufficiently large numbers of tourists to justify the building of resort hotels. These large and elaborate hotels were particularly appealing for an urban populace not able or willing to buy a wilderness estate. The Mt. Washington Hotel, one of the last of the grand resort hotels in New Hampshire, is a classic example of White Mountains resort hotels. Those in the Lakes Region have vanished.

Groups of summer visitors to Shaker Village were modest in size (from ten to twenty people per group) in the late nineteenth century because transportation from Laconia was by horse and carriage. No accounts reveal exactly what the world's people did on their visits to the Shakers, but we can surmise that the visit included a tour, at times a meal, direct conversation with the Shaker leadership, and an opportunity to buy gifts and souvenirs; the Shaker Gift Shop became a staple by the 1890s.

Tourism accelerated with the advent of the automobile. To help provide

for increasing numbers of visitors and cars, the Shakers added a wing to the Trustees' Office in order to expand their gift shop. The 1909 wing was fitted with a porte-cochere so that automobiles could discharge and pick up passengers in inclement weather. This concession to a new era no doubt pleased the Shakers as much as it did their visitors, for the Shakers' own automobiles are often pictured in snapshots under the porte-cochere.

Visiting Americans have always craved souvenirs. In one respect these souvenir purchases can be seen as diminutive versions of "trophies" of the hunt, or of the lavish purchases abroad of art and antiques by the wealthy. They were also "memory" devices. The Shakers had little to offer visitors who wanted status symbols or bragging rights. That would come later when they started to sell their own Shaker antiques. Rather, the Shakers offered low-cost hand-made souvenirs of direct contact with a unique religious society. Shaker souvenirs were reminders of what must have been a most memorable day with a distinctive people in a place of great mystery and beauty.

What did the Shakers offer to their visitors in the nineteenth century? Without going into great detail, it is safe to say that the Shakers offered a well-ordered village, a presentation on their way of life, an array of hand-made goods, and commercially produced visual images. The goods included food products such as maple sugar and flag root candy, maple syrup, honey, and crafts, such as woven poplar fancy work and knitted articles. The commercial visual images included stereographs in the late nineteenth century and view cards after 1900.

Today we know the view card as a postcard. We still see them as useful souvenirs, but they are not as highly regarded now as they were in the early twentieth century. Then the cards were novel and prized so much that they were avidly collected. The craze reached its peak between 1905 and 1915, but remained strong until personal travel was curtailed by the Great Depression.

The Shakers produced some postcards from their own photography, but most of the surviving views were commercially produced. Most of the views are exterior pictures, although a few show the interior of the Chapel and the interior of the dining hall in the Dwelling House. They rarely show Shakers at all until after World War II. The Church Family Cow Barn is a favorite subject, as is the Meeting House, and panoramic scenic views are popular. The early-twentieth-century cards are typical of those produced elsewhere in the United States in that they highlight newer buildings and technological improvements and show a village that is serene and secure.

This picture changes dramatically after World War II. In the late 1940s and early 1950s, Shaker Village was administered solely by eldresses, and financial hardship was setting in. However, the Shakers themselves are now frequently portrayed in the cards. Granted, all are older women, but they are portrayed at work and leisure in a series of charming and personal scenes that bring out the gentility of the last generation of Canterbury Shakers. The visual images the Shakers commissioned in the early 1950s reflected the reality of their daily lives and their desire to meet the curiosity of a revitalized America. The Shakers were few enough to be known personally, and the public was hungry to meet one of the last of the Shakers and carry home a "memory" card.

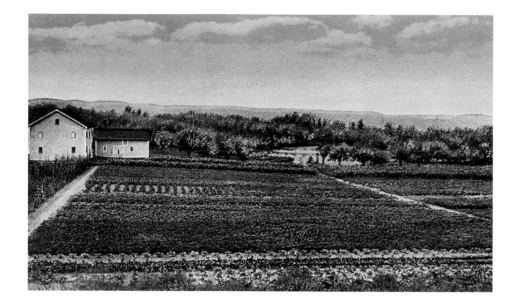

Figure 13 "The Family Garden." The Canterbury Shakers began selling medicinal herbs in 1824 and then garden seeds in 1829. The Church Family vegetable garden, seen here, covered three acres and was 380 feet long. A Garden Barn and Garden Shed stand on the left, and Turning Mill Pond is in the background. [46-P220]

Figure 14 "Main Dwelling. Built 1793." The Church Family Dwelling House, built in 1793, was subsequently altered several times as needs changed. In 1832 a belfry was added (with a 500-pound Paul Revere and Sons bell), but it was so high that it met with the disapproval of the Central Ministry at the New Lebanon Shaker community; it then had to be lowered by 5 feet 5 inches. The dwelling reached its final form in 1837 when a 2 ½-story ell containing a large meeting room (the Chapel) was built onto the north side of the building. The kitchen was on the basement level, and sleeping rooms were on the upper floors. In its current form the Dwelling House has 56 rooms, 3 ½ stories (including the basement level), 13 bays, and a gable roof. [24-PC101]

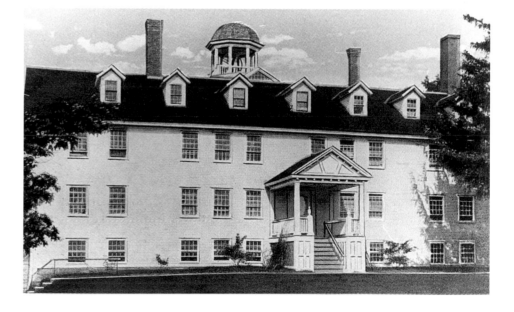

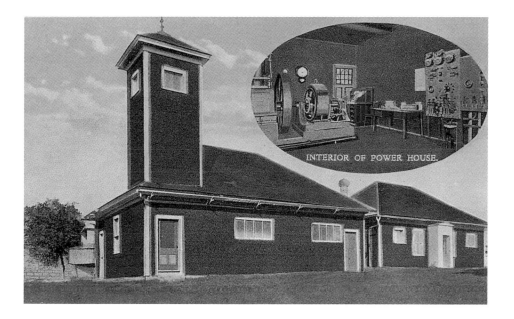

Figure 15 "The Garage and Power House." These pressed metal buildings were built in 1908 (the Garage) and 1910 (the Power House), with wood frames and metal siding. The Garage was also used as the Church Family's fire house, whereas the Power House contained the community's direct current generator and storage batteries. The inset in the upper right shows the "Interior of Power House." [24-PC97, 26-PC38]

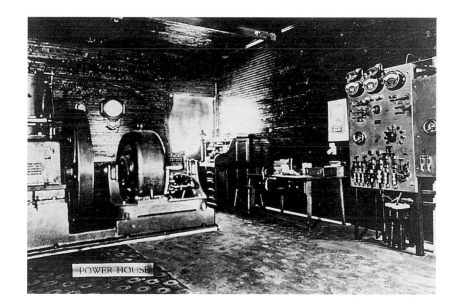

Figure 16 "Interior, The Power House." This shows the generator (left) and the main switchboard (right), which controlled the flow of direct current to buildings throughout the Church Family. [26-PC5]

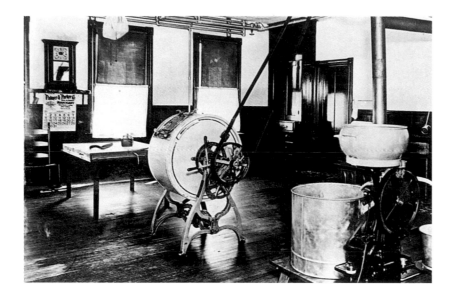

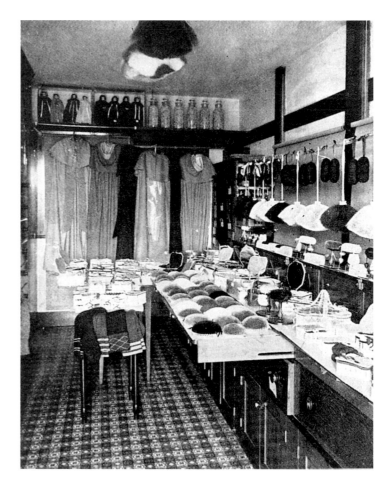

Figure 17 "CREAMERY." The Church Family "Creamery," or dairy, was constructed in 1905, and the wall calendar in this postcard shows that the photograph was taken in August of 1915. A butter-churn appears at the left-center, and the small vat above the stove at the right-center was heated to make cheese. [Album 38]

Figure 18 "Sales Room" in the Church Family Trustees Office, showing various examples of fancywork, small domestic items such as pin cushions, sewing boxes and baskets. Many hundreds of visitors to Canterbury made their purchases here each summer. [24-PC110]

Figure 19 "Barn and Silos." The north side of the Church Family Cow Barn. The barn was 200 feet long and 45 feet wide, but 25-foot ramps installed at either end brought the total length to 250 feet. While it once held a herd of over 100 registered Holsteins and Guernseys, these were let go in 1920 when the Shakers decided they could no longer maintain their dairy business. [P176]

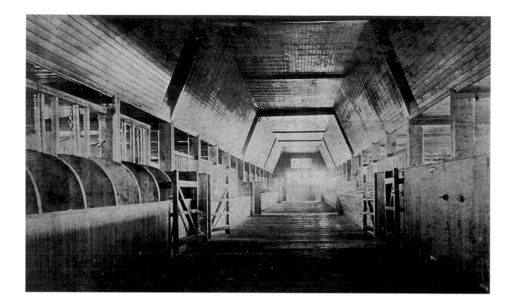

Figure 20 "Interior of Barn Central Walk." The central aisle inside the Church Family Cow Barn, ca. 1915, with a feeding floor 200 feet long and hay lofts that could hold over 400 tons of hay. [24-PC106]

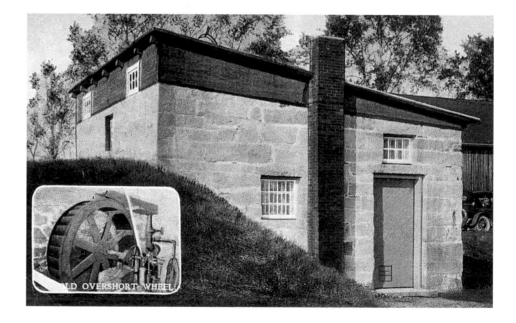

Figure 21 "Pumping Station." The 1905 Pump Mill built alongside Ice Mill Pond (also known as Factory Pond). This was used to pump water to cisterns in the North Orchard; from there, the water traveled south to the Church Family. The inset, showing the interior of the Pump Mill, reads "Old Overshort [*sic*] Wheel." [24-PC103]

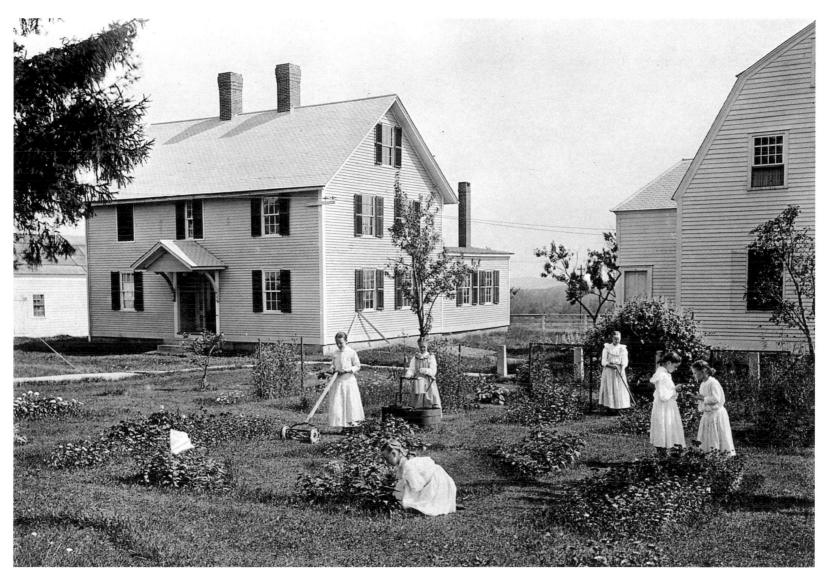

Figure 22 Shaker recruitment postcard. Scenes such as this one, showing girls at work just outside the Church Family Meeting House, were used to attract new recruits (chiefly orphans) to the community. Active recruiting became increasingly important as membership fell, but ultimately the Shakers could not compete with state-run orphanages. [24-P120, 26-PC7]

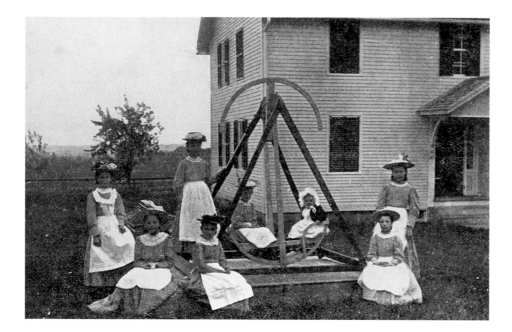

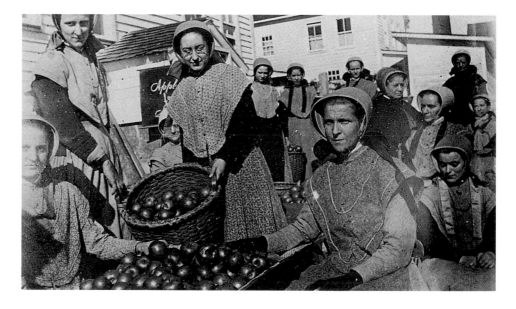

Figure 23 "Children at Play." Girls who lived with the Canterbury Shakers were expected to take part in gymnastic exercises, whereas boys played ball and marbles, fished, and maintained small garden plots of their own. This swing is located just outside the main (north) entrance of the Church Family Ministry Shop. [24-PC120]

Figure 24 "Sorting apples in 1914." Canterbury sisters sorted apples just outside the east (cellar) entrance of the Church Family Sisters' Shop. Sister Marguerite Frost is second from left, and Sister Bertha Lindsay is third from left. Orchards of fruit trees—apples, plums, peaches, cherries, and pears—were located in many places around the village, and the sale of apples was a significant source of outside income. The actual picking and sorting was conducted by the Canterbury sisters, although brothers might help with some of the heavier chores. [11-P198, 31-P108]

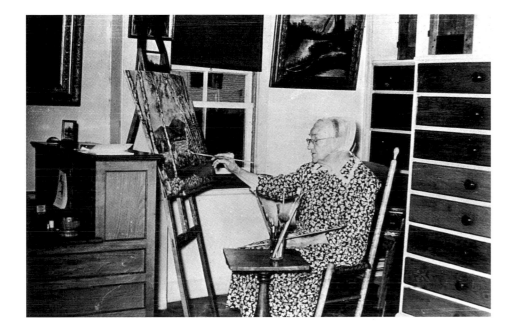

Figure 25 "Sister Helena." Sister Cora Helena Sarle (1867–1956) painted in her studio on the second floor of the Church Family Syrup Shop. Helena Sarle was the most prominent painter who resided in Canterbury. She created hundreds of oil paintings (chiefly landscapes) over the course of her lifetime. According to Sister Bertha Lindsay, "Sister Helena also could do beautiful handwork, like crocheting and knitting, making many articles for our gift shop. She also helped on the cloakmaking." [24-PC140]

Figure 26 "Brick Oven. Evelyn." Sister Evelyn Polsey, ca. 1940, filled cardboard containers with baked beans which had cooked overnight in crocks; they were then taken to Concord, New Hampshire, for sale. The revolving bake oven (left), patented in 1876 by Eldress Emeline Hart, was located on the basement floor of the Church Family Dwelling House. When fully loaded, the oven could hold up to sixty pies at a time. [24-PC145]

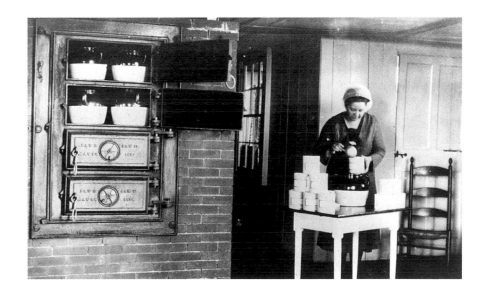

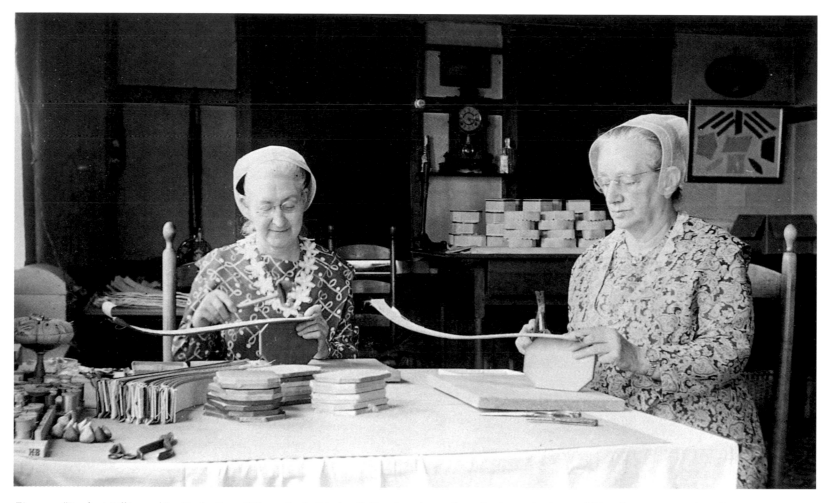

Figure 27 "Bertha & Lillian making Poplar Boxes." Sisters Bertha Lindsay (left) and Lillian Phelps made fancywork for sale in the village's gift shop, including poplar boxes. Sister Bertha was in charge of this industry in Canterbury from 1944 until 1958. [24-PC144]

Leaders and Followers

✳ The organization of each Shaker village provided for a well-defined hierarchy of brothers and sisters, deacons and deaconesses (in charge of daily operations), trustees (responsible for business dealings with the outside world), and elders and eldresses who were the ultimate religious and secular authorities. While the ordinary brothers and sisters were the most numerous and performed most of the work in a Shaker community, they were typically assisted by dozens of boys and girls who had not yet chosen whether to become Shakers. And, in turn, the children were educated and taught practical skills by the Shakers, necessary whether or not they chose to remain in the community. The presence of solid leadership no doubt helped determine which Shaker villages were the more long-lived, and Canterbury never lacked for leaders who were good administrators. Under such able leaders as Henry Blinn, David Parker, Mary Whitcher, and Dorothy Durgin, Canterbury prospered throughout the nineteenth century and subsequently outlasted many of the other Shaker villages.

During the formative stages of Canterbury Shaker Village in 1792 and later, Benjamin Whitcher provided the leadership necessary to hold the community together. And well into the future, members of the Whitcher family continued to play a central role in the village's management. The duration of this family's influence is perhaps best exemplified by his granddaughter, Mary Whitcher (1815–1890), who served as a trustee and minister some seventy years later. The economic success of the village during its early years was due in no small part to the skills of Trustee David Parker (1807–1867), who was unusually effective in his business dealings with the outside world. However, there is no doubt that the talents of Elder Henry Blinn (1824–1905) helped sustain Canterbury throughout the second half of

the nineteenth century. Blinn's skills as a minister, printer, teacher, and author provided Canterbury with much-needed stability, while establishing him as one of the most revered and admired Shakers of his day.

However, given the dual nature of Shaker society, women leaders were just as crucial to the success of the community, and prominent eldresses included Dorothy Durgin (1825–1898), Emeline Hart (1834–1914), Lucy Ann Shepard (1836–1926), and Dorothea Cochran (1844–1912). Chief among these was Dorothy Durgin, who designed the popular "Dorothy" cloak and composed many inspired Shaker songs. Eldress Dorothy was appointed an eldress at the age of twenty-four and held the position of first eldress of the Church Family until her death many years later.

In the 1790s there were as many Shaker men as women in Canterbury, but later there were typically many more sisters than brothers, perhaps because Shakerism offered women more opportunities for equality than in the outside world. As males failed to join the Society, Canterbury increasingly became a woman-dominated village. By 1900 only about a third of the Shakers were men, and this had shrunk to just two individuals—Arthur Bruce and Irving Greenwood—by the 1930s. Both men needed to perform an exhausting variety of male-specific roles, including all of the mill work and farming, although sometimes with help from hired men. But when Elder Arthur died in 1938 and Elder Irving in 1939, Canterbury ceased to be a dual-sex society, and many of the field chores could no longer be performed. Farm managers—the first of which had been trained by Irving Greenwood—took up some of the slack, but much of the community's vitality was gone.

With the passing of Eldress Bertha Lindsay in 1990 and Sister Ethel Hudson in 1992, it is no longer possible for visitors to talk with the Canterbury Shakers, or to watch them at work or relaxing in their homes. Also, while most sisters kept diaries, nearly all private records were deliberately destroyed when each Shaker died so as not to violate their privacy. Consequently, what has survived in print tends to be the "official" church records

kept by Shaker men, describing business transactions, deaths, journeys, and construction activities. It is only in the photographs taken by the Canterbury Shakers that it is still possible to glimpse how they conducted their daily lives and, perhaps, to get a sense of their personalities. While the earliest photographs were formal, austere, studio portraits, the later images show the Shakers relaxing, eating, teaching children, enjoying birthday parties, or simply posing on the lawn for a group portrait with their friends.

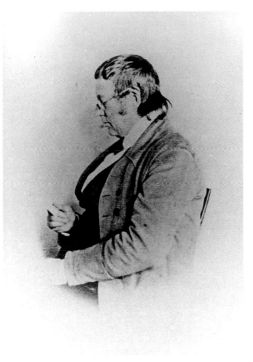

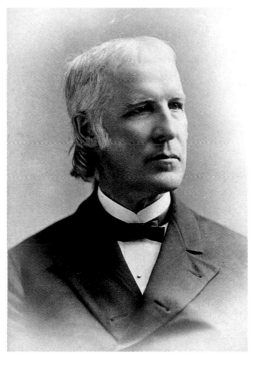

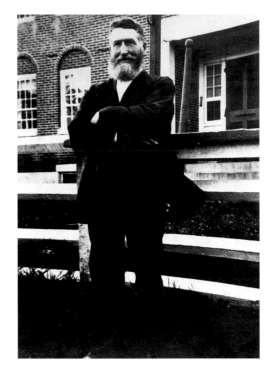

Figure 28 David Parker, Trustee (1807–1867). Canterbury's most distinguished Trustee was born in Boston and was received into the Church Family in 1817. He became an Assistant Trustee in 1826 and was a full Trustee from 1828 to 1837 and 1846 to 1867. He was an unusually gifted manager, and his ability made him one of the most respected businessmen in New Hampshire. In 1857 he invented a new model of steam-powered washing machine, for which he took out a patent on Jan. 26, 1858. [8-P38]

Figure 29 Elder Henry C. Blinn (1824–1905) was easily Canterbury's preeminent Shaker, working throughout his life as a beekeeper, printer, teacher, minister, dentist, preacher, and writer. He was born in Providence, Rhode Island, which was the birthplace of many of the Shakers who lived in Canterbury. He was received into the Church Family in 1838, signed the Covenant in 1846, and was a Junior Minister from 1852 to 1859. He was also Assistant Elder in the Church Family in 1852, became Senior Elder in the Church Family in 1859, and Senior Minister in 1880. Blinn began printing *The Shaker Manifesto*, a monthly newspaper, when it moved to Canterbury in 1882, and it continued under his management until 1899. He kept many of the most detailed written records of the Church Family, wrote a biography of Mother Ann Lee, and ultimately died of valvular heart disease in 1905. [8-P22, P2]

Figure 30 "Elder Freeman White—No. Family, Canterbury Shakers." Elder Freeman White (1844–1913) was the son of David White and Betsy Bailey, both Shakers. He was the last elder of the Canterbury North Family. According to Sister Bertha Lindsay, "He was a wonderful speaker, and we knew when he was to speak in church that we would have to sit very quietly and listen because his speech was quite long and very profound." [No album no.]

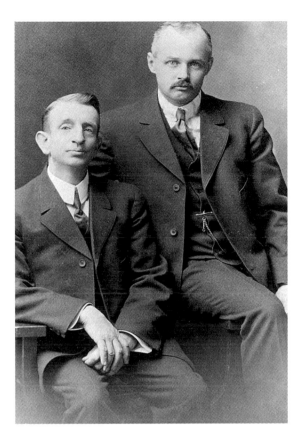

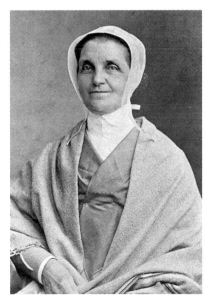

Figure 31 "Arthur Bruce—Irving Greenwood." Elder Arthur Bruce (left) was born in Springfield, Massachusetts, in 1858 and arrived in Canterbury in 1885 (after being admitted to the Enfield, Connecticut, Shaker Village in 1874). He signed the Church Family Covenant in 1887, was appointed Trustee in 1892, became an elder in 1899, and became a Lead Minister in the Parent Ministry in 1919 (together with eldresses from the Mount Lebanon Society). Perhaps best known for his love of horses and for managing Canterbury's business affairs in the early twentieth century, Elder Arthur died of pneumonia in 1938.

Brother Irving Greenwood (right) was born in Providence, Rhode Island, in 1876 and entered the Society in 1886. As the youngest, and final, Shaker brother to live in Canterbury, he supervised and participated in a phenomenal range of activities. He worked in the mills and fields, helped with the fancywork business, installed electrical wiring and plumbing throughout the village, transported the Canterbury sisters in the village's cars, kept journals, and became Lead Minister in 1933. Curiously, his cause of death in 1939 was listed as "shock." Photograph by Kimball Studio. [8-P19]

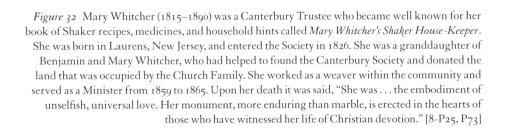

Figure 32 Mary Whitcher (1815–1890) was a Canterbury Trustee who became well known for her book of Shaker recipes, medicines, and household hints called *Mary Whitcher's Shaker House-Keeper*. She was born in Laurens, New Jersey, and entered the Society in 1826. She was a granddaughter of Benjamin and Mary Whitcher, who had helped to found the Canterbury Society and donated the land that was occupied by the Church Family. She worked as a weaver within the community and served as a Minister from 1859 to 1865. Upon her death it was said, "She was . . . the embodiment of unselfish, universal love. Her monument, more enduring than marble, is erected in the hearts of those who have witnessed her life of Christian devotion." [8-P25, P73]

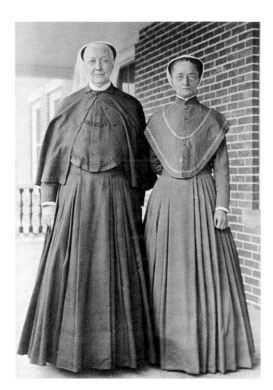

Figure 33 "Dorothea Cochrane—Emma King." Eldress Dorothea T. Cochran (left) was born in 1844 in Duntalker, Scotland, and was received from the North Family into the Church in 1857. She signed the Church Family Covenant in 1866, became an Assistant Eldress in the Church in 1879 and Senior Eldress in 1898 (after the death of Dorothy Durgin, designer of the well-known "Dorothy" cloak). She died in 1912 of a cerebral hemorrhage, at which time Emma King (right) was appointed an Assistant Eldress.

Eldress Emma King (1873–1966) was born in Providence, Rhode Island, and was received into the Church Family in 1878. She signed the Covenant in 1894, became Assistant Eldress in 1913, First Eldress in 1918, and subsequently entered the Parent Ministry in 1946 and became Lead Minister in 1947. She was a schoolteacher for many years and was unquestionably the most influential Shaker of the mid-twentieth century. She was instrumental in overseeing the closing of several Shaker villages, and in the 1950s she liquidated many Shaker assets in order to create a trust fund with which to perpetuate those few villages that survived. [24-P62, P90]

Figure 34 "Goldie I. R. Lindsay[,] Canterbury N.H." Sister Bertha Lindsay was twelve years old when this portrait was taken in 1909 by Kimball Studio in Concord. Born in Braintree, Massachusetts, in 1897, Bertha was received into Canterbury as a pupil in 1905. She signed the Church Family Covenant in 1918 and spent the rest of her life in the Church Family, eventually becoming an eldress in 1967 and a major spiritual force in the community during its transition to a museum village. She was in charge of the fancywork industry and was an avid photographer. Bertha Lindsay was the very last Shaker eldress when she died in 1990. [P671]

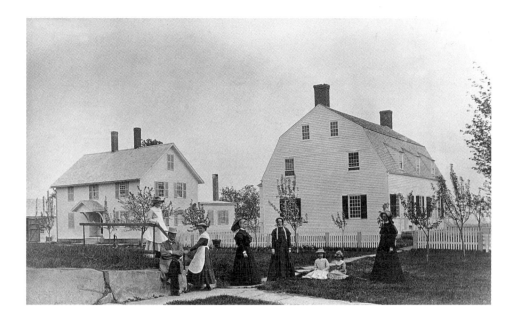

Figure 35 A formal portrait (pre-1905) of several Canterbury Shakers and girls on the lawn north of the Church Family Meeting House (right) and Ministry Shop. Elder Henry C. Blinn is seated in the left foreground. [P86]

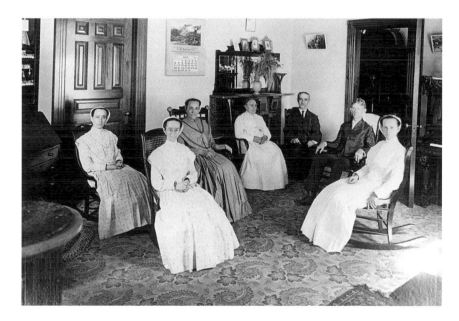

Figure 36 Canterbury sisters and visitors seated inside the Church Family Trustees' Office for a formal portrait, 1913. Portraits such as this helped to accentuate the image of the Shakers as overly serious and austere, but in casual snapshots it was much easier for their natural warmth and humor to shine through. [P97]

Figure 37 Girls next to "The Shelter" (left), which was a screened-in summer house. Sister Blanche Gardner (right) was born in New York City (1873–1945) and arrived at the village in 1881. She signed the Covenant in 1894 and later served as Trustee, worked as a bookkeeper, made cloaks, and handled the shipping of sale items. [11-P228]

Figure 38 Girls seated in front of "The Shelter." [14-P26]

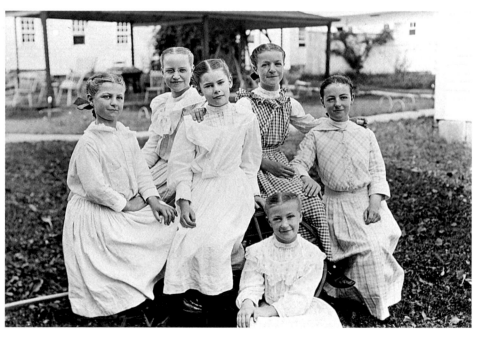

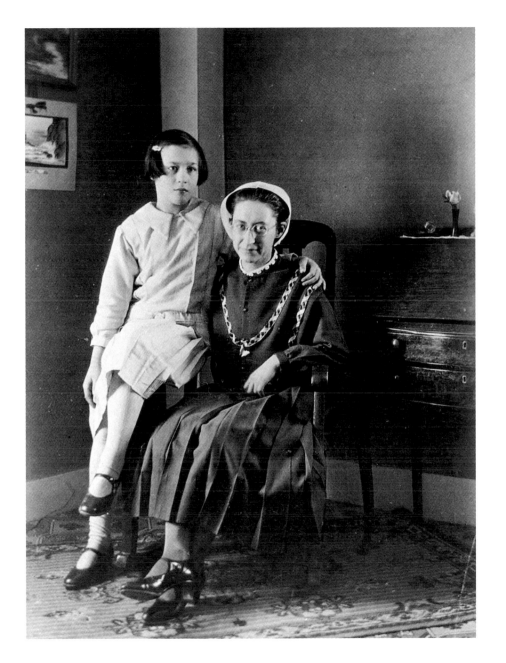

Figure 39 "Rosamond & Bertha." Rosamond Stark with Sister Bertha Lindsay (right). Rosamond was one of the many girls raised by the Canterbury Shakers who elected not to become a Shaker upon reaching maturity at age twenty-one. [13-P129, P108, PN138]

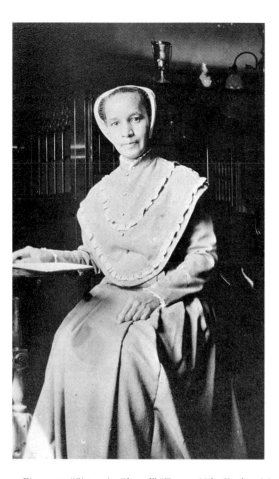

Figure 40 "Edith Green." Sister Edith M. Green (1879–1951) in front of the piano in the Church Family Dwelling House. Of mixed racial parentage, her father was a sailor, born in St. Thomas in the Dutch West Indies, and her mother came from Maine. Born in Gloucester, Massachusetts, Edith Green was admitted to the North Family in 1895 and to the Church Family later that year. She went back to the North Family in 1896, signed the Covenant in 1914, and went to the Church Family again in 1915 where she stayed for the rest of her life. She was in charge of the Creamery, canned food, and made sweaters and crocheted goods. A college graduate, she was one of extremely few Black Shakers in Canterbury. [9-P70]

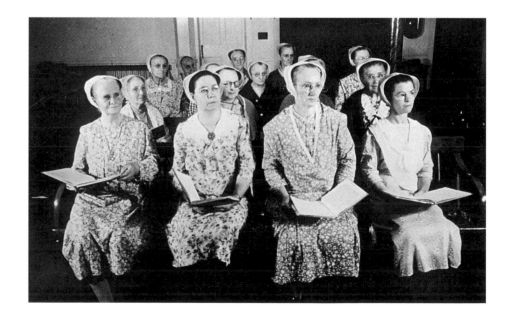

Figure 41 "Sisters in Chapel" "F row. Aida, Evelyn, Marguerite[,] Ethel[,] Mary. Bertha[,] Eldress Mary. Flora[,] Lillian." When the Meeting House ceased to be used for worship services, the Chapel inside the Church Family Dwelling House became the favored site for religious services in the twentieth century. Twentieth-century services were held on Sunday mornings and consisted of Scripture readings, exhortations, personal testimony, prayer, and the singing of hymns. Shown at worship in the 1950s (front row, left to right) are Sisters Aida Elam, Evelyn Polsey, Marguerite Frost, and Ethel Hudson. Also shown in various parts of the photograph are Alice Howland, Emma King, Flora Appleton, and Ida Crook. [24-P157]

Buildings and Interiors

✳ The architectural heritage of the Canterbury, New Hampshire, Shakers is noteworthy from at least two viewpoints. First, the Shakers established a collective building process through which they achieved an extensive and prosperous planned community in two generations, from their call to order in 1792 to 1858 when the village reached its physical peak. Second, the Canterbury Shakers developed a distinctive village plan, which incorporated overall Shaker architectural ideas of form and function but organized them in a pattern not characteristic of other Shaker communities.

Throughout their history, the Canterbury Shakers built over one hundred structures—organized into four Shaker families (Church, Second, West, and North)—on more than three thousand acres of land. The pace of construction continued unabated from 1792 until the late 1850s, when the main agricultural complex was greatly enlarged by the construction of a two-hundred-foot cow barn, the largest frame barn ever built in the State of New Hampshire. The village did not begin as a planned community, but the Central Ministry at New Lebanon, New York, directed that each community exercise discipline over its communal lands, specifically by erecting a Meeting House. General guidelines for community planning and the construction of particular building types would follow from the example of the Central Ministry at New Lebanon. The Millennial Laws of 1845 contained two specific building instructions, designed to prevent "beadings, mouldings and cornices, which are merely for fancy" and "odd or fanciful styles of building." Shaker buildings developed a "common style" of architecture that was essentially a streamlined Federal or Neoclassical idiom. Although this "style" was accepted as appropriate at all Shaker sites, it was not explic-

itly described in the Millennial Laws. Also, no common Shaker settlement plan was provided to individual communities. The Canterbury Shakers were given latitude to achieve "heaven on earth" in their own way once the Meeting House was built and the Church Family established.

Accordingly, Canterbury's Church Family Meeting House was completed in September of 1792, and this was followed by the construction of a Dwelling House in 1793, a two-and-one-half-story "curb" or gambrel structure that included a basement level for a communal dining room. From 1792 to 1817, the Canterbury Shakers built continuously, erecting twenty-eight structures, of which only six survive. These today are known as the Meeting House (1792), Dwelling House (1793), Laundry (1795), Carpenter Shop (1806), Children's House (1810), and Infirmary (1811). The completion of the Cow Barn in 1858 brought to a close some sixty-six years of nearly continuous building. This was followed by a period of consolidation, maintenance, and selective rebuilding. Victorian elements were added to many of the buildings, and further modernization brought an array of floor cloths and linoleum, the addition of indoor plumbing (1880–1939), and electrical wiring (1908–1915). An extensive telephone system was installed in 1901, but most buildings never received central heating.

Building activity during the 1904–1918 period reached a level unmatched since the early 1850s. Many of the buildings experienced major remodeling, and a new Creamery was constructed in 1905 to expand capacity for milk processing and butter making. At least six buildings in the village core were moved or torn down, principally to make way for new structures. However, by 1916, the Church Family was the only active family of Shakers at Canterbury. From 1916 into the 1940s the surviving buildings of the Second and North families dwindled rapidly through loss by fire, dismantling, or sale. Today, only the Trustees' Office survives from the North Family, and two buildings remain from the Second Family (a small barn and the Office, which was moved to the Church Family in 1918—now termed the "Enfield House").

After the death in 1939 of Elder Irving Greenwood, no new buildings were erected at the Church Family. In fact, the 1940–1975 period was one of accelerated subtraction, as buildings were destroyed by fire, sold and dismantled, or simply torn down. To date only one of these buildings has been located. The Canterbury Horse Stand survives as the "Shaker Shed" at the Shelburne Museum in Vermont, having been sold in 1951 to the founder of Shelburne, Electra Havermeyer Webb. Twenty-four original Shaker buildings remain at Canterbury Shaker Village, which is now recognized as a National Historic Landmark. The rest of the Shaker buildings survive only as archaeological sites and as information on historical maps, references in Church Family records, and in historical photographs.

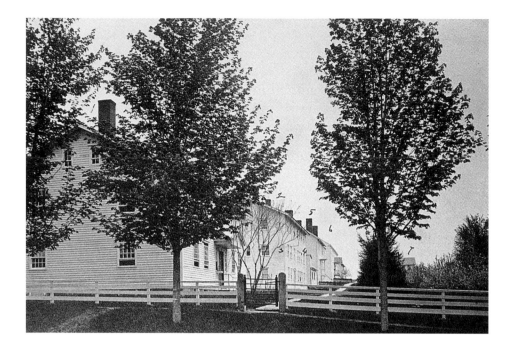

Figure 42 "Buildings of the Canterbury Church Family: 1. Infirmary; 2. Brethren's Shop; 3. Elder Henry Blinn's room in the Brethren's Shop; 4. Printing Office in the Brethren's Shop; 5. Sisters' House; 6. Dwelling House; 7. Children's House; 8. Meeting House." Photograph by William Kimball. [Courtesy Shaker Museum and Library, Old Chatham, New York]

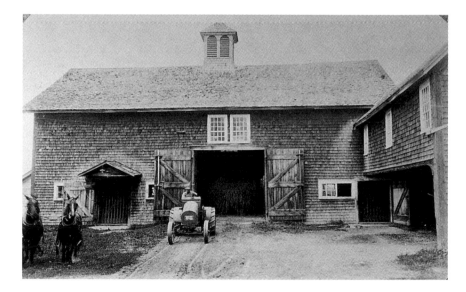

Figure 43 "[U]nloading hay at horse barn." The Ministry Horse Barn was constructed at the Church Family in 1819, and a large addition was built (on the right) in 1824. This building has gone through numerous renovations, most recently in 1991 to return it to its appearance at the time of this photograph (ca. 1905). [Album 39]

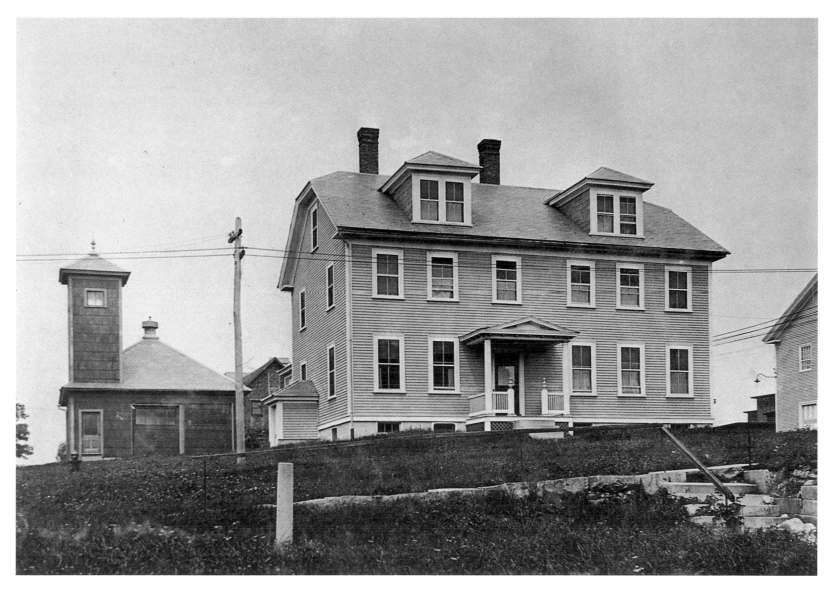

Figure 44 "Built in 1905." The Creamery, or dairy, was constructed by non-Shakers in the center of the Church Family in 1905. Measuring 30 feet by 40 feet, it has two stories, an attic, and a full cellar. The sisters who were engaged in dairying lived in this building. [Album 39]

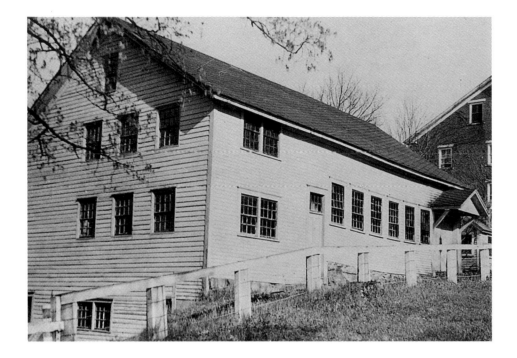

Figure 45 "S. E. Blacksmith's Shop. 1812. House V." The Church Family Blacksmith's Shop was constructed in 1811 with brick forges, and in 1849 these were removed and replaced with cast iron forges. There was a room at the north end of the building for shoeing the oxen, and tinware was made on a lower level. The building was finally taken down in the mid-1950s. [79–P14]

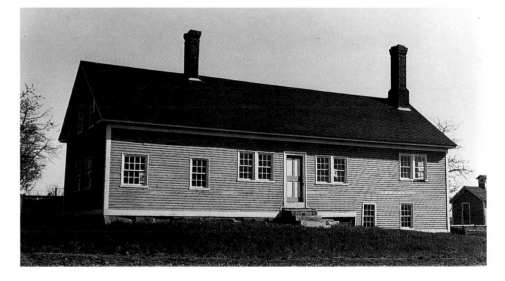

Figure 46 "Old Dry House built 1797. [D]own 1938." The central part of this garden shop (used for drying apples and corn) was built in 1797, the eastern addition in 1799, and the western addition sometime prior to 1826. The asphalt shingles were added in 1926, and then the building was removed in either 1938 or 1939. The Bee House (built in 1837) was located just east of the Dry House (at the right in this photograph), prior to being moved to its present location east of the East Wood Shed. [15-P69, 1-PN530]

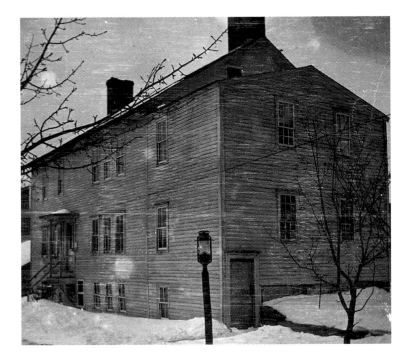

Figure 47 "Second House, 115 yrs. old. Taken down in [1911]." The Second Dwelling House of the Church Family as it appeared in February or March of 1910. It was built in 1794 and was long used as a dairy for the Church Family. After the Second House was torn down in 1911, the Enfield House was moved into this location. [31-P3]

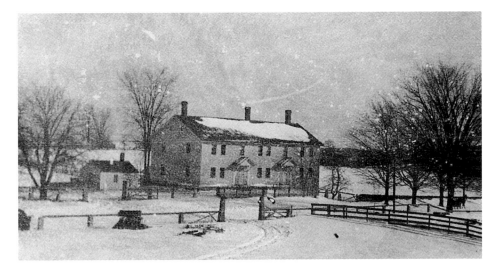

Figure 48 "Moving the Enfield House from Branch to Church." The Enfield House at the Second (Branch) Family in 1918 just before it was moved to its current location in the Church Family. It received the name "Enfield House" because elderly sisters came to reside here after the disbanding of the Shaker Society in Enfield, New Hampshire. [Album 39]

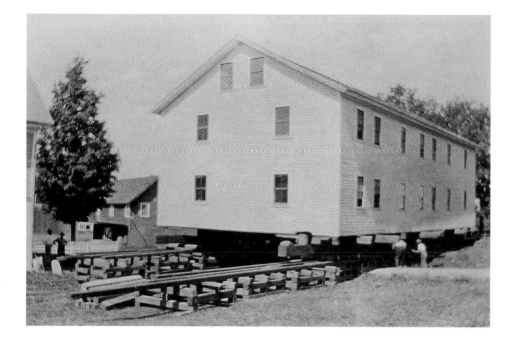

Figure 49 "This was the Trustees' or Office at second family and stood on right hand side of road. [W]as movcd to its prcscnt site at Church family in 1918." The Enfield House was moved on rollers to its present site, with Shaker photographers thoroughly documenting the move. Once it had been refurbished in its new location, this sisters' dwelling had living and sleeping rooms on the first and second floors, and looms in the basement for weaving poplar wood into fancywork. [14-P44, P192, PN131]

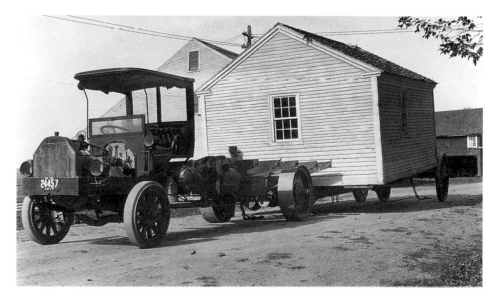

Figure 50 The Canterbury Shakers were well known for moving buildings (or tearing them down) as needs changed. Henry Hutchin's truck, shown here, was used to move the Cheese House in the fall of 1918. In the background are the Church Family Horse Stand (left rear) and the Ministry Horse Barn (right rear). The Horse Stand was sold to the Shelburne Museum in 1952 and removed at that time. [1-PN318]

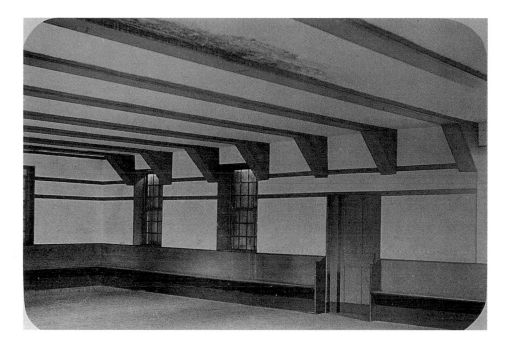

Figure 51 Interior of the Church Family Meeting House. The first floor interior is completely open, with no supporting posts, and the floor structure is a heavy, double frame set on stone and floored with two overlapping layers of one-inch hard pine—clearly designed to absorb the impact of synchronized group dancing. The interior woodwork was originally painted dark blue but was later repainted light blue in 1878. [Courtesy Shaker Museum and Library, Old Chatham, New York]

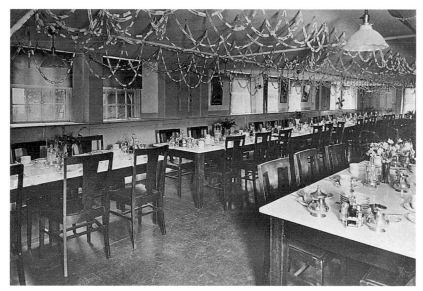

Figure 52 "Dining Hall[,] Opal Glass Tables." "Dining-room in Dwelling-house." The dining hall in the Church Family Dwelling House accommodated sixty Shakers at a sitting, with brothers and sisters, elders and eldresses, dining at separate tables. These glass-topped tables and wooden chairs were ordered in 1914 at a total cost of $383. Low-backed chairs were used which could easily be pushed under the tables. [12-P3, 14-P3]

Figure 53 "Interior School house at close of school." "School-room decorated for Examination Day." The Church Family School House was originally built as a one-story structure in 1823 but received a second story in 1863 and an organ in 1880. After 1863 the rows of pupils' desks all faced north toward the teacher's desk, which was on a low platform. Boys and girls, including many non-Shakers, took their classes together here until 1921. Classes for the few remaining "Shaker girls" were subsequently moved to the Church Family Dwelling House. [25-P9, Album 38]

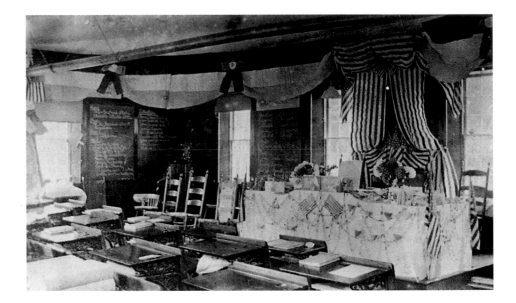

Figure 54 "Views of Musical Instruments in Chapel." "[O]rgan room in meeting room." The Chapel inside the Church Family Dwelling housed the Shakers' pipe organ, as well as a Victrola (background, with lamp on top), and Brother Irving Greenwood's crystal radio (right). [15-P109, 1-PN498]

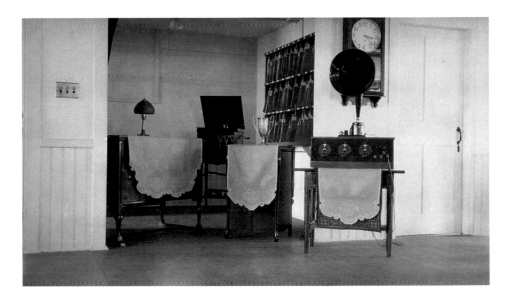

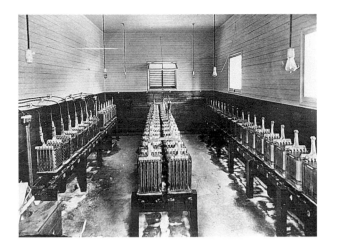

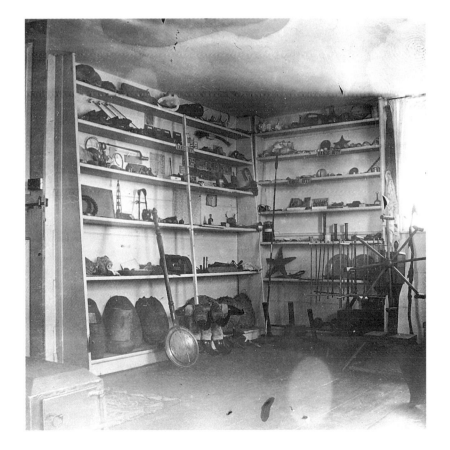

Figure 55 "Wet Cell Batteries in Power House." The Church Family Power House contained rows of storage batteries and a gasoline engine that ran a 125-Volt direct current generator. The cost of the plant was about $8,000, and it powered electric lights in sixteen Church Family buildings. The system became obsolete in 1925 when an A. C. electric line was run to the village, and the batteries were finally sold and removed in 1937. [14-P7]

Figure 56 A Shaker "museum" of relics gathered by Elder Henry Blinn. These objects were at one time housed in the Church Family Brethren's South Shop (built in 1795 and torn down in 1918) but were subsequently moved to the Church Family Dwelling House where some are still on display today. Objects pictured in the museum include an eight-day clock, a human skeleton, early styles of shoes and pottery, coins, and an old-fashioned bed warmer. [4-PN60]

Industries and Agriculture

✳ Every Shaker village became known for its distinctive products and manufactures, and Canterbury was renowned for its orchards, seeds, cattle, light industry, and print shop. Many of the Canterbury brothers worked in shops, outdoors in the fields, and in the mill buildings that had been constructed along the eastern side of the village. Their activities included sawing wood, turning wood into broom handles and buckets, performing carpentry, making bricks, the fashioning of tin, and even manufacturing washing machines, cast iron stoves, brass clocks, and hats. Shaker sisters, on the other hand, performed many of their tasks indoors, including knitting sweaters, crocheting, sewing, cooking, canning, processing corn, dairying, making feather dusters and pin cushions, house-cleaning, etc. Brothers and sisters also taught their tasks to boys and girls, respectively, and all rotated their jobs frequently to ensure that there would always be several individuals capable of performing each task. This was even true of those who taught in the Shaker public school, and good teachers were expected to rotate in and out of craft activities as well.

Of the dozens of tasks that needed to be performed in Canterbury, a significant number of these were documented on film. Irving Greenwood and the hired men who assisted him were often photographed as they tedded and windrowed hay, threshed oats, plowed the garden, plowed snow, and tended the farm animals, and on a few occasions they were filmed as they worked inside the most recent sawmill (built in 1915).

Harvesting ice from the surface of Ice Mill Pond (Factory Pond) and Turning Mill Pond was an important industry, and production figures show that a few thousand cakes of ice were obtained each year in the early

1900s, to be sold to the outside world. This was only one of many industries, however, and Canterbury was rather atypical of Shaker villages in that it developed an extensive mill system on a series of man-made ponds. At various times the Shakers operated saw and grist mills, wood mills, turning mills, a fulling mill, a carding mill, a tannery, a clothiers' mill with large power looms, a threshing mill, and an ice house. Work in and around the mills eventually came to an end with the passing of the last brothers, and there was no attempt by the sisters to assume the industrial tasks that had been proscribed for men only. Outdoor work activities considered appropriate for women were fairly limited but included apple-sorting and stacking firewood.

There is no question that the rigidly proscribed separation between male and female activities was resolutely maintained, although in the 1930s Irving Greenwood worked together with the Shaker sisters in the preparation of poplar wood for manufacture into "fancywork." After the death of Brother Irving, the fancywork industry was continued by the Canterbury sisters through the 1970s.

In addition to industrial pursuits, diversified, small-scale agricultural production was a mainstay of Canterbury's economy throughout most of the village's history, although farming per se was never quite as important as at most of the other Shaker villages. This may have been because the most cultivable land was restricted to the fields surrounding the Church, Second, and North Families, while the more remote lands were relatively stony and usable only as wood lots. Orchards were extremely successful, however, and Canterbury's apple orchards included such varieties as Delicious, McIntosh, Baldwins, Arkansas and Canada Reds, Yellow Transparent, Pippins, Winesap, Jonathan, Wealthies, and Maiden's Blushes.

In 1829 garden seeds began to be cultivated in a field just east of the Church Family. Highly profitable, the garden seed industry lasted until 1846, after which the field was adapted to vegetables instead. Roots and

medicinal herbs were grown both in Canterbury and nearby Concord. Sugaring was also profitable, with the maple sugar camp located about two miles southeast of the Church Family. In 1836 the *American Magazine of Useful and Entertaining Knowledge* described Canterbury as having "two thousand acres of stony soil on which were raised grass, corn, grain, and potatoes." Statements such as this reinforce the impression that the Shakers' agricultural potential was rather limited.

Dairying proved to be one of the more successful farm activities, and dairy products were first processed in the Old Second House at the Church Family. Later, in 1905, a modern Creamery was built in the center of the Church Family, and cheese and butter were sold in large quantities, with Shaker sisters handling most of the work. Eldress Bertha Lindsay liked to reminisce in her later years about how, as a very young girl, she would go to the Old Second House every day to get a pail of milk.

By the twentieth century, with only a few Shaker brothers left, hired men took over most of the field chores. Increasingly, it was paid employees who plowed, threshed, and hayed, all under the supervision of Arthur Bruce or Irving Greenwood. However, employing non-Shakers was less profitable and also reduced the community's "separateness" from the outside world. Eventually, though, the few remaining farm chores were taken over by a single farm manager, beginning with Richmond McKerley in 1939. From that time on, there were relatively few good sources of income for the Shakers, except for limited craft production and the fancywork industry.

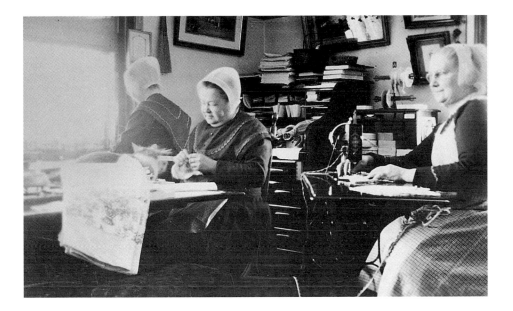

Figure 57 The first sewing machine owned by the Canterbury Society was purchased in 1849 at a cost of $150. The sisters had sewing rooms in the Church Family Sisters' Shop, where sewing machines and work tables stood close to the windows. Early, diversified production was ultimately replaced by a specialization in Shaker cloaks that were sold by the thousands to the outside world. [11-P44, 12-P190]

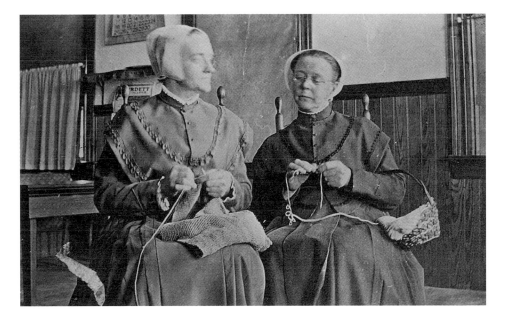

Figure 58 "Sister Jessie[,] left. Sister Helena[,] right." Sister Jessie Evans (actually on the right) was born in Liverpool, England, in 1867 and entered the Canterbury Society in 1881. After signing the Covenant in 1888, she became a schoolteacher and nurse in the community. Here she is knitting with Sister Helena Sarle (left). [P89]

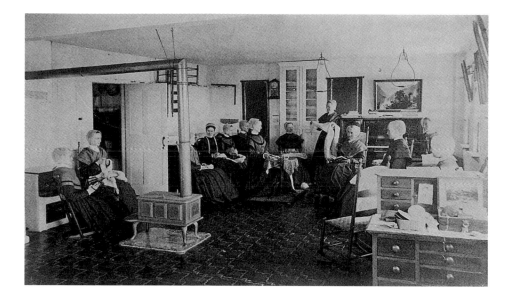

Figure 59 "Interior view of Sister's Shop." Canterbury sisters knitting inside the East Room of the Church Family Sisters' Shop: Josephine Wilson, Elmira Hillgrove, Sarah T. Wilson, Jennie Fish, Elizabeth Sterling, Eldress Harriet A. Johns, Iona Crooker, and Mary L. Wilson. [P87]

Figure 60 "Rebecca & girls at Syrup Shop making dusters." Several sisters, including Rebecca Hathaway (1872–1958), instruct young girls in the making of feather dusters. Most instruction consisted of older sisters and brothers working with the young and teaching them practical skills that could be employed if or when they returned to the outside world. Working together not only prevented monotony but ensured greater uniformity of product. [9-P40]

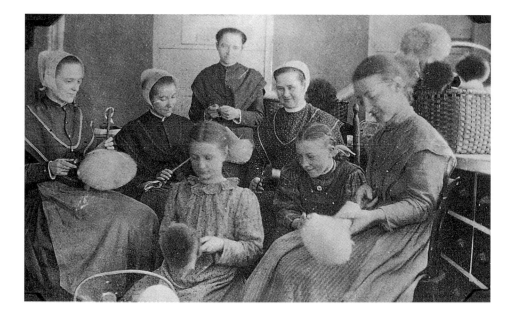

Figure 61 "Jessie Evans." Sister Jessie Evans (1867–1937) seated at her desk in the Church Family Schoolhouse. According to Sister Bertha Lindsay, Sister Jessie "was a very learned and intelligent woman" and one of the most popular Shaker schoolteachers (personal communication, March 6, 1982). Sister Jessie taught for about twenty years but was not allowed to focus exclusively upon teaching because of the Shaker custom of rotating individuals among several different tasks. [P944]

Figure 62 "Jessie Evans, teacher & her class outside school house," 1904. During the early years of the Canterbury community, boys were taught for twelve weeks in the winter and girls for twelve weeks in the summer. However, by the early years of the twentieth century, the school had expanded to thirty-six weeks a year, six hours a day. While the Shakers' school was considered to be far superior to public schools, it finally was forced to close in 1934 because of economic hardships brought by the Depression. [P88]

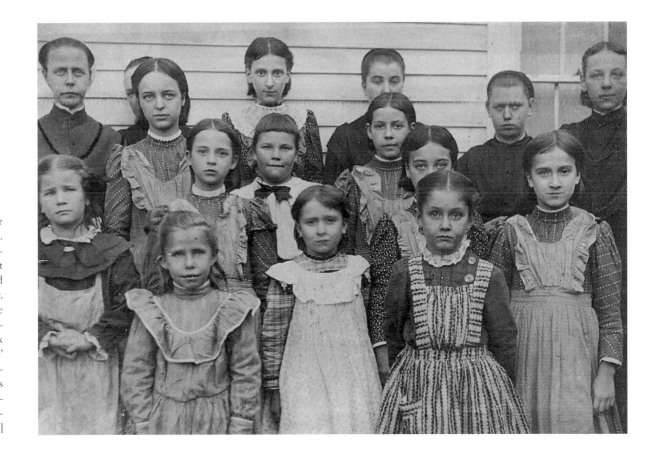

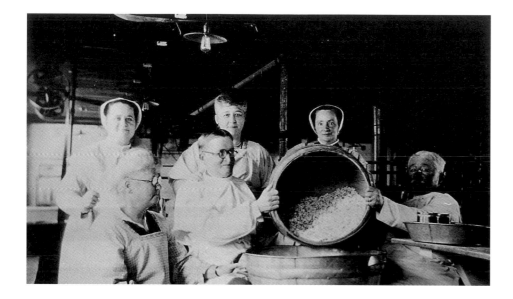

Figure 63 Sisters Rebecca Hathaway (at left rear), Lillian Phelps (second from right), and friends pouring popcorn inside the Church Family Laundry, ca. 1922, probably to make popcorn balls. The Laundry was the favorite location for making popcorn balls because the corn could be popped over the hot coals in the ironing room or the wash room. Molasses was boiled to the right temperature and then poured over the popcorn balls, after which everyone shared in the treat. [11-P21, 12-P110]

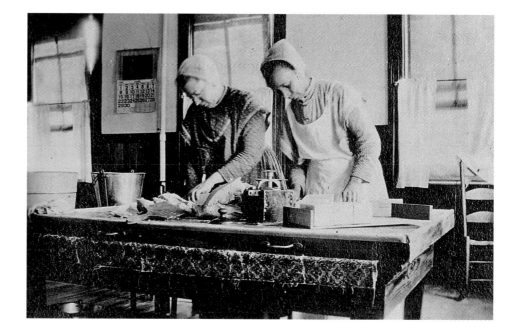

Figure 64 "In Dairy. Cora Mead & Edith Green." Sisters Cora Mead (left) and Edith Green in the Church Family Creamery in June of 1919, packaging butter for sale. The Creamery was built between 1903 and 1905 by contractors from Manchester, New Hampshire, thus becoming the first Church Family building to be erected entirely by non-Shakers. Cheese and butter were an important source of revenue for the Canterbury Shakers, and several sisters lived on the second floor of the Creamery building, close to their work. [12-P160]

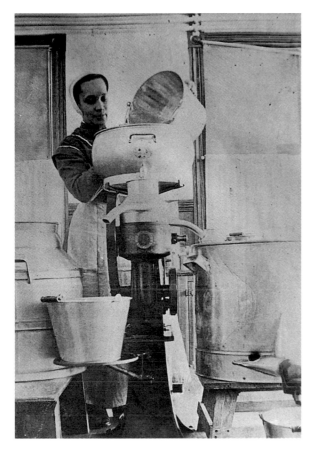

Figure 65 Sister Edith Green pouring milk into a milk separator in the Creamery. [No album no.]

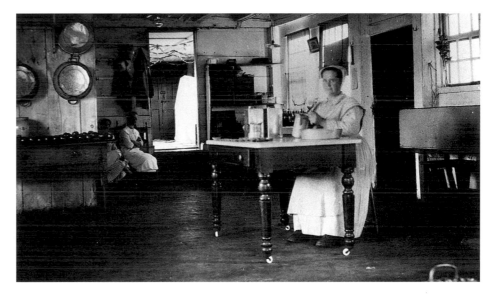

Figure 66 Sister Rebecca Hathaway preparing maple sugar cakes in the north room on the first floor of the Church Family Syrup Shop, ca. 1930. In some years the Canterbury Shakers produced thousands of pounds of maple syrup, maple sugar cakes, fudge, and pulled candy. In addition to manufacturing confections for sale, Sister Rebecca was Kitchen Deaconess from 1912 until her death in 1958. As such, she was responsible for canning produce, pickling, and overseeing the garden harvest.

The Syrup Shop, constructed in 1797 as a grain store, was the setting for numerous other activities, especially the manufacture of Syrup of Sarsaparilla. But in 1919 the sarsaparilla kettles were taken out, and a brick wood-burning stove was added so that it could be used as a canning kitchen. [11-P269, 12-P249]

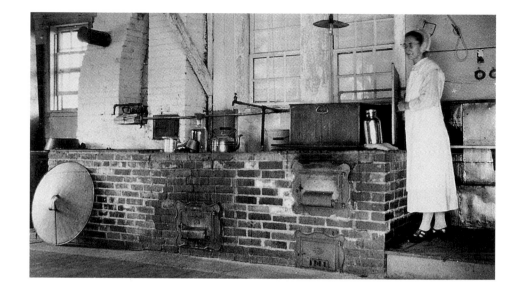

Figure 67 The "canning arch" on the first floor of the Church Family Syrup Shop, ca. 1935. The Shakers raised extensive crops of vegetables and even purchased land along the Merrimack River in Concord for this purpose. They prepared thousands of jars of fruits and vegetables each year for their own consumption and for sale, and wild blackberries, cranberries, strawberries, and blueberries were also gathered to be made into preserves and pies. Sister Bertha Lindsay (standing on the right side of the arch) began to help with canning, especially jams and jellies, when she was a teenager and assisted Sister Rebecca Hathaway in processing the cans and glass canning jars for thirty years, up until 1957. The sisters also used the canning arch, up until Prohibition, for the manufacture of patent medicines. The most popular of these was Thomas Corbett's Syrup of Sarsaparilla, dating back to 1841. [11-P271, 12-P247, 1-PN488]

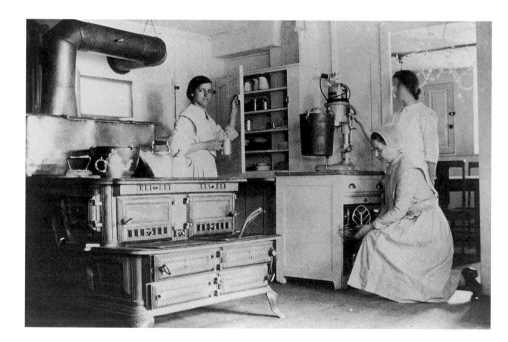

Figure 68 The "Family Kitchen" in the Church Family Dwelling House. Sister Evelyn Polsey (kneeling) and two girls are flanking a Kitchen Aid electric mixer where they are about to make ice cream, ca. 1926. The kitchen was extensively remodeled in 1909, at which time two new ranges were installed; one of these stands at the left. New electric fixtures were also added to the kitchen in 1929. [9-P97, PN237]

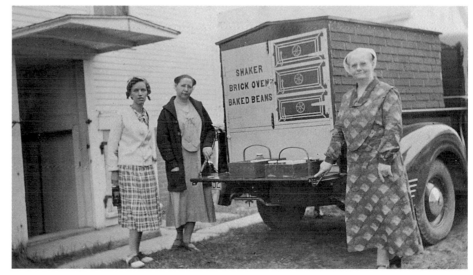

Figure 69 Sister Aida Elam (1882–1962) operating the Kitchen Aid in the kitchen of the Church Family Dwelling House, ca. 1926. Sister Aida was born in Providence, Rhode Island, and entered the Canterbury Society in 1893, signing the Covenant ten years later. She was an excellent cook but also was a schoolteacher, played the cello, and even directed "entertainments" for the village. [11-P235, 12-P183]

Figure 70 "Eleanor Parmenter[,] Evelyn Polsey[,] Aida Elam[.] Packing cart ready to sell beans." Sisters Evelyn Polsey (center) and Aida Elam (right), as well as Eleanor Parmenter and Sister Gertrude Roberts, baked beans and brown bread in the 1930s and 1940s to sell locally and in Concord. They loaded the beans into the "Baked Bean truck" (shown here), which was decorated with the image of the revolving oven in the basement of the Dwelling House; the truck was driven by one of the hired men. [14-P91, P255]

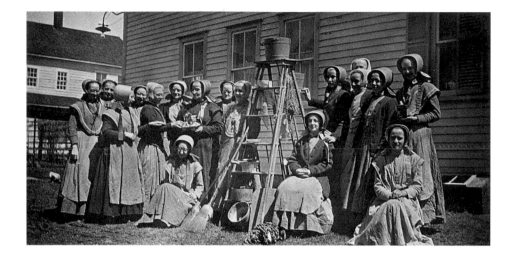

Figure 71 "The Housecleaning Brigade with usual weapons. Lillian [Phelps] (without bonnet) stands between two sisters (with bonnets) on right side of steps." Spring cleaning was accomplished by "the House Cleaning Brigade" as groups of sisters went from building to building, sweeping and scrubbing. Sister Bertha Lindsay is seated on the left, at the foot of the stepladder. [57-P40]

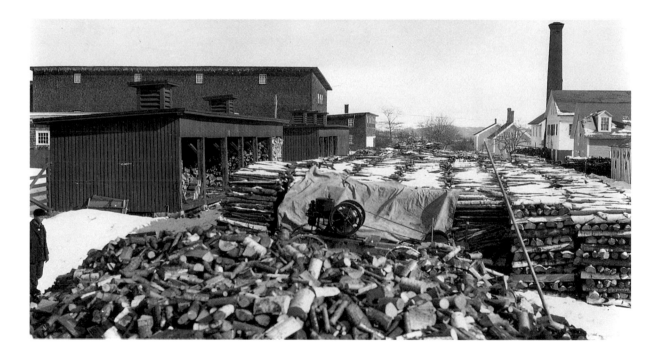

Figure 72 "Views of 500 cords of wood for Winter use." The Canterbury Shakers used about 500 cords of firewood in their stoves each winter. Here, on the northern edge of the Church Family, a wood splitter stands in the middle of the pile of wood. The East and West Wood Sheds appear on the left. [15-P107, 24-P93, 1-PN104]

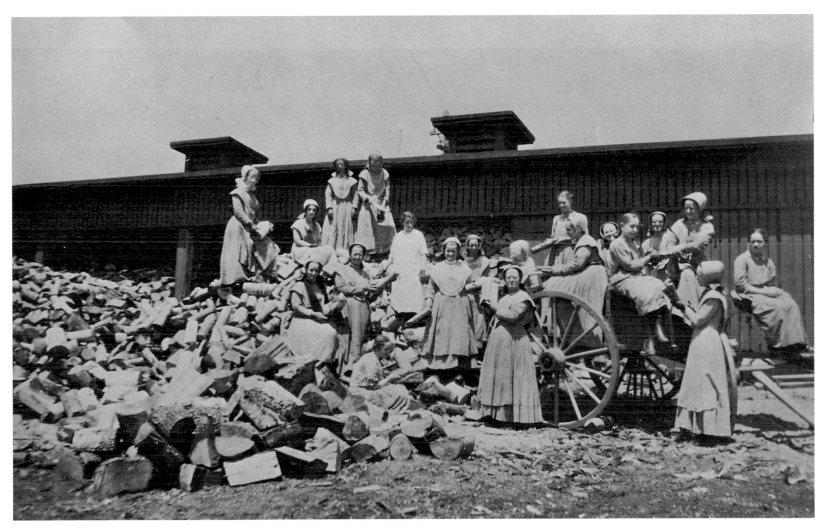

Figure 73 Stacking wood. Every winter, firewood was piled in front of the Church Family woodsheds, and in the spring it was cut and split. The Canterbury sisters then formed a relay line to stack it inside the woodsheds. [74-P125]

Figure 74 "[P]oplar views." Brother Irving Greenwood (left) and a hired man planing poplar wood inside a sawmill, ca. 1932. (The machinery for making poplar fancywork had been purchased from Mount Lebanon, New York, in 1928.) The poplar was cut into 24" lengths in the winter when it was frozen in order to craft it into "fancywork." [1-PN504]

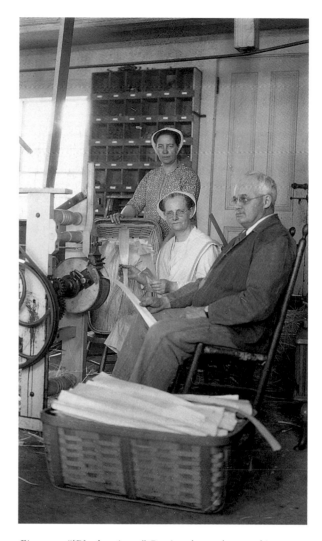

Figure 75 "[P]oplar views." Cutting the poplar wood into strips suitable for weaving with the gauge inside the Church Family Laundry, ca. 1932. Right to left: Brother Irving Greenwood feeding the gauge; Sister Aida Elam passing the strips; and Sister Evelyn Polsey catching the strips in a basket. [1-PN502]

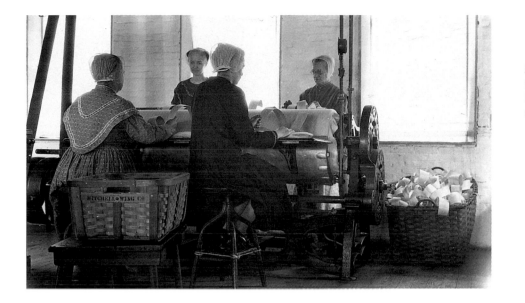

Figure 76 "[P]oplar views." Flattening poplar wood on the "mangle" in the Church Family Laundry, ca. 1932. Left to right: Sisters Blanche Gardner and Frieda Weeks, unknown, Eldress Emma King. [1-PN501]

Figure 77 "[P]oplar views." Weaving poplar wood on looms in the basement of the Church Family Enfield House, ca. 1932. Sisters Flora Appleton (left), Marguerite Frost (center), and an unidentified sister are weaving the strips of wood into fancywork which, when lined with satin, became sisters' bonnets and sewing boxes. [1-PN499]

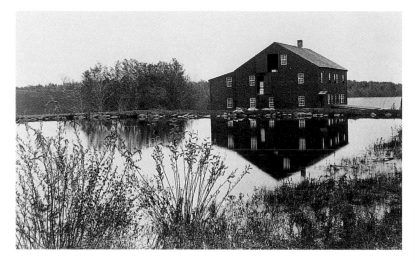

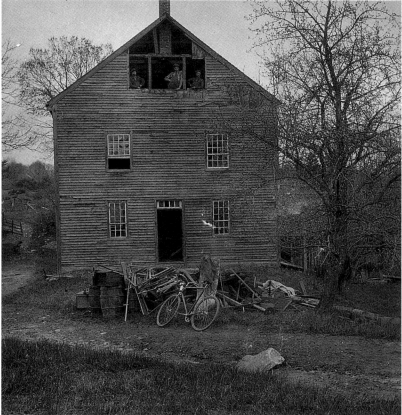

Figure 78 "Turning Mill, East Canterbury, N.H." The water-powered Church Family Turning Mill, built in 1818 at the south end of Turning Mill Pond, was the largest (40 by 30 feet) of the Canterbury mill buildings and was used for making pails, brooms, and hoops, polishing metals, and pulverizing barks and medicinal roots. It was taken down in 1916; none of the manufacturing equipment has survived, but the foundation is plainly visible. [Album 46]

Figure 79 "Weaving Mill being razed." The Church Family Clothiers Mill was constructed in 1828 on Ice Mill Pond and was where the Canterbury sisters fulled and dressed woolens and flannels. It was dismantled in May of 1905 because it was no longer needed and had become too expensive to maintain. A Pump Mill was then constructed in the same location. [30-P38, 31-P73, 4-PN38]

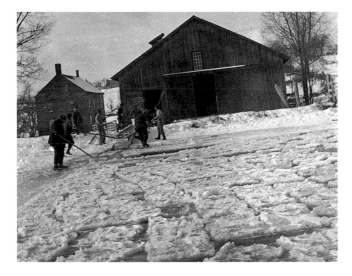

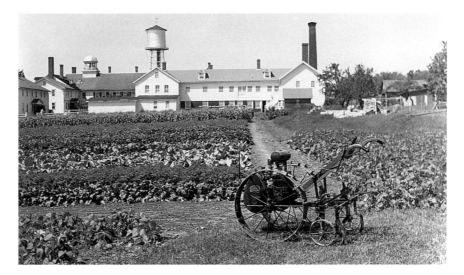

Figure 80 Hired men harvesting ice on Turning Mill Pond (pre-1905). Ice on the pond was cut into blocks of 22" x 22" x 15", and a conveyor belt was used to carry blocks of ice to the second floor of the Ice House/Threshing Mill. When packed in sawdust, the ice would keep from melting until May or June, and this business was actually expanded as recently as 1914 when the Threshing Mill was removed and the size of the Ice House was doubled. However, this industry came to an end when the village acquired three Fridgedaires in 1929. [No album no.]

Figure 81 "East view of Laundry & Vegetable garden." Looking west at the Church Family Vegetable Garden, with a gasoline cultivator in the foreground. It was the responsibility of the Kitchen Deaconess, assisted by other sisters, to pick the peas, beans, beets, and other crops from the garden. These were then canned and stored for the winter. In the rear are the Church Family Laundry building (right) and the water tower (center). Completed in 1901, the combined tower and tank were 92 feet high, and the cypress tank had a capacity of 22,000 gallons. The steel water tower was erected over a well at the corner of the Dwelling House and supplied water in case of fire. It was taken down in the 1950s. [24-P140, 1-PN548]

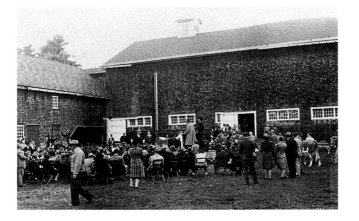

Figure 82 "Auction of cattle." After Elder Arthur Bruce decided that the Society's herd of Holsteins and Guernseys was no longer needed, Canterbury's cattle were sold at auction in 1920. The Church Family's *Historical Record* noted in May of 1920: "We sell our entire herd. All but a few animals that Paul and Stewart of Canterbury buy, are sold to Mr. J.M. Price, County Agent of Tacoma, Washington. . . . Sell the Guernseys for $4000.00 Holsteins $3075.00. They go in Armstrong Palace Cars attached to fast passenger trains." The Church Family Cow Barn is in the background, to the rear of the auction proceedings. According to Sister Bertha Lindsay, Elder Arthur "watched from the top of the hill as the cows left and cried to see them go." [Private Collection]

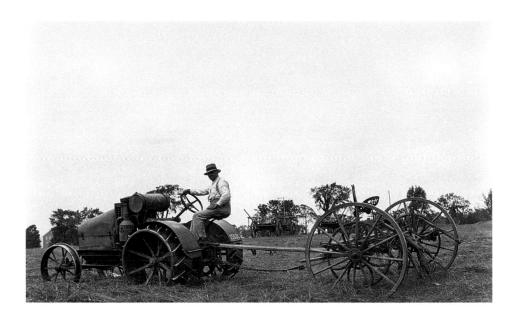

Figure 83 "Haying in Meetinghouse Field." "Tedding Hay."
Brother Irving Greenwood tedding hay in Meeting House Field.
[15-P137, 24-P96, 1-PN66]

Figure 84 "Haying Time at Canterbury, N.H." A side delivery
rake windrowing hay just southwest of the Brethren's Brick
Shop at the Second (Middle) Family. [24-P103, 1-PN55]

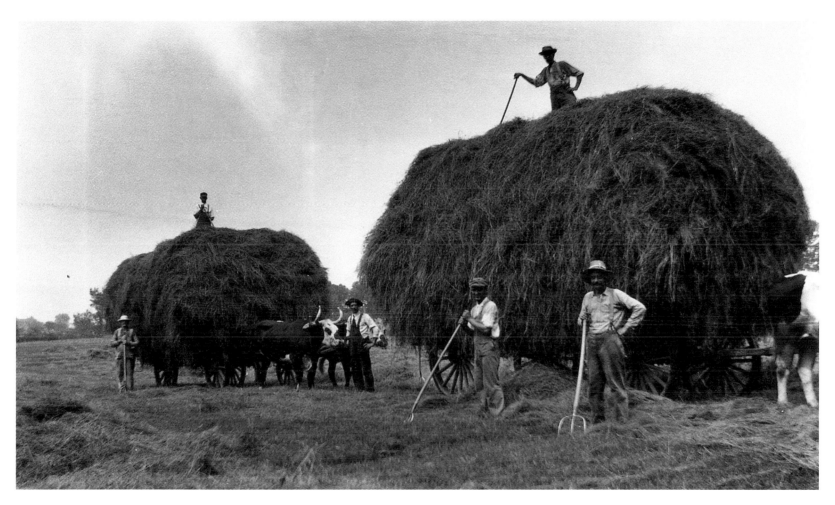

Figure 85 "Haying in the North Field." Hired men working in the North Barn Field, ca. 1924. They were being supervised by Brother Irving Greenwood, who took this photograph. The Canterbury Shakers used oxen for all heavy pulling chores and maintained between twelve and twenty yoke of oxen. Here the oxen are being used to pull the hay wagons.

According to Sister Bertha Lindsay, "Brother Irving apparently repeatedly told the men to pile more hay onto the wagons, even when the men protested that the wagon might collapse. After Irving took the photograph, the men could not fit the wagon through the barn door, as the load of hay was too wide. It sat outside overnight and 'exploded' the next morning." [24-P111, 1-PN52]

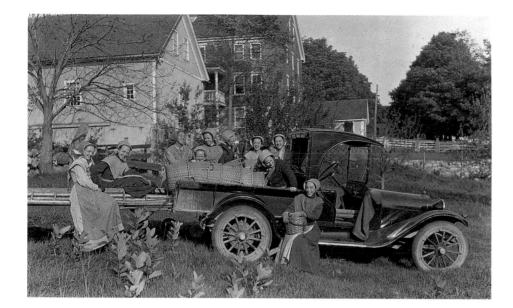

Figure 86 "Apple Picking, 1918." Canterbury sisters relaxing in the back of the farm truck, preparing to go apple picking, October 1918. The sisters included Frieda Weeks, Edith Green, Josephine Wilson, Lena Crook, Ethel Hudson, Lillian Phelps, Bertha Lindsay, and Florence Phelps. Sister Florence Phelps (seated at far right) holds a basket with a hook attached, which made it easier to pick apples with both hands free. At the rear are the Church Family Trustees' Office (left) and Woodshed (far left). [1-PN110]

Figure 87 "Apple Picking, 1918." Canterbury sisters taking a lunch break during apple picking, October 1918. Left to right: Sisters Josephine Wilson, unknown, Ethel Hudson, Frieda Weeks, Edith Green, Lillian Phelps, Lena Crook, Bertha Lindsay, and Florence Phelps. Note the picking basket on the ground at the left. After picking the apples, the sisters sorted them into three grades. "Number One" apples were the highest grade and suitable for sale, and the rest were either eaten raw, dried, or used for baking, canning, sauces, applesauce, cider, and vinegar. After they were sorted, the apples were stored in bins in well-ventilated apple cellars, designed to preserve the apples for as long as possible. [1-PN112]

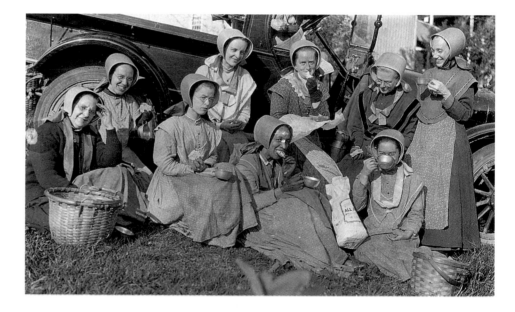

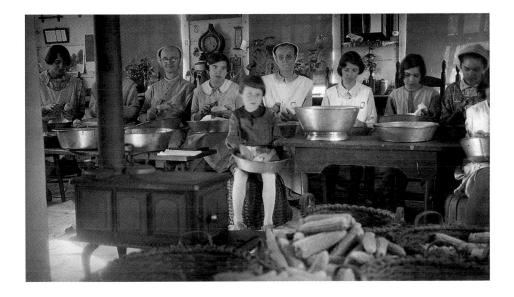

Figure 88 "Sisters working on corn in the Syrup Shop." Canterbury sisters, with Flora Appleton seated in the center, shucking corn in the south room on the first floor of the Church Family Syrup Shop, ca. 1929. While many Shaker tasks were highly repetitive—such as sorting apples or processing food—much of the time the sisters labored in large groups, which helped to reduce boredom. [11-P274, 12-P116, 1-PN544]

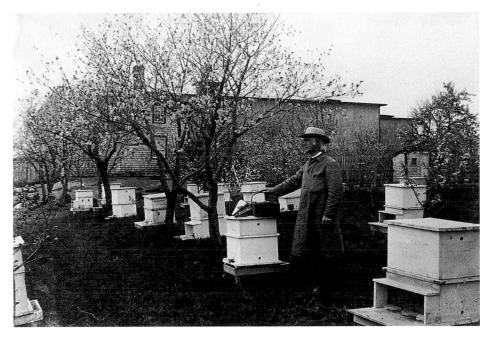

Figure 89 "Elder Henry and his Bees." Elder Henry Blinn (1824–1905) tending his bees, which helped to keep the many Canterbury orchards pollinated. In the rear is the Church Family Cow Barn. [Album 46]

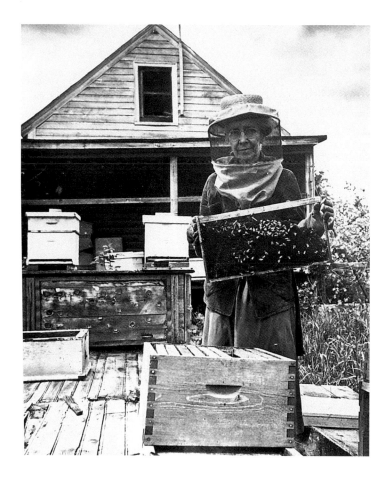

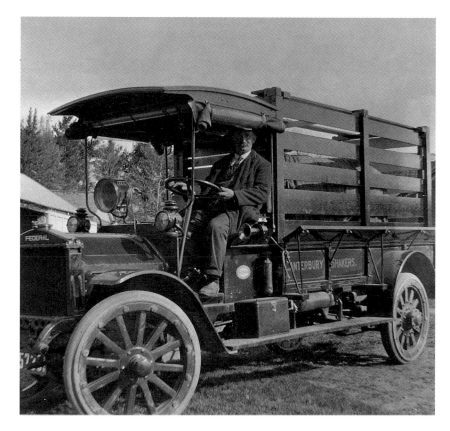

Figure 90 "Alice Howland with her bees. Taken around 1950." Sister Alice Howland was born in Lowell, Massachusetts, in 1886 and arrived in Canterbury in 1899. After signing the Society's Covenant in 1914, one of her principal duties was to tend bees, one of the very few occupations that successfully evolved from a male into a female activity. Sister Alice was also an accomplished artist, although she did not produce pictures for sale. [No album no.]

Figure 91 "[T]rucks" and "Irving with cow for Mr. Tyler." One of the hired men (not Irving Greenwood) is transporting a cow in the "Federal" 1 ½-ton truck that was owned by the Canterbury community from 1915 to 1928. The village's first farm vehicle was a white Stanley Steamer (1913), followed by the Federal, and then a Ford tractor (1919), International tractors (1922 and 1928), and an International 1 ½-ton truck (1928). In the rear are the Church Family Cart Shed (left) and the Cow Barn (right). [25-P15, 1-PN32]

Leisure Activities

✳ Leisure activities are often overlooked in discussions of Shaker life, giving the unfortunate impression that the Shakers may have been a rather austere and humorless people. Admittedly, the prodigious achievements of the relatively few Shakers, and the rigorous schedule of Shaker daily life, suggest that Shakers had minimal leisure time. And the rarity of known Shaker toys for children, along with the long-standing prohibition against novels and pets, also reinforce the concept that work and worship prevailed at all times. However, while many photographs depict the Shakers at work, the vast majority of images reveal the Canterbury Shakers enjoying card games, hay rides, sleigh rides, sledding, making snow men, going on picnics, boating in the summer, making popcorn balls, visiting the beach, holding costumed theatricals, singing, and performing with a wide range of musical instruments. As new technology entered their lives, the Shakers also added bicycle riding, photography, nighttime reading by electric lights, and evenings with the radio.

Music, in particular, held a very special place in Shaker life. It figured prominently in the education of children, and Canterbury was the most prolific center for the writing and performing of Shaker music, including thousands of hymns. Much of the music was considered to be divinely inspired, and songs were passed among the various Shaker communities. Musical instruments were introduced into the community in the 1870s, and a later twentieth century development was the creation by the Canterbury Shaker sisters of numerous small instrumental groups in which they performed on harmonicas, saxophones, trumpets, and stringed instruments. Vocal training was required in the community, and Shakers from Canter-

bury taught music to the Shakers at other societies as well. Singing groups such as the "Qui Vive Quartet" and the "Qui Vive Trio" performed at concerts around the country.

In their spare time, the Shakers held picnics alongside Ice Mill Pond (Factory Pond) and often rode their boats on Lake Winnisquam where they owned a camp known as "Point Comfort." Photographs show them eating large slices of watermelon on the porch at Point Comfort, and frequently their dogs and cats accompanied them. The Millennial Laws of 1821 had prohibited pets, but with time had come a softening of the Laws, and dogs, cats, parakeets, horses and cows all became pets for the Shakers. Perhaps the most popular of these was Irving Greenwood's dog "Dewey," which traveled everywhere with his master. During the final years of life in Canterbury, Eldress Bertha Lindsay greatly enjoyed her dog "Penny," which lived with her in the Church Family Trustees' Office, whereas Sister Ethel Hudson had a six-toed cat named "Buster," which lived with her in the Dwelling House.

For sheer fun, perhaps nothing equaled wintertime activities when the Shakers rode in sleighs drawn by horses, danced in the snow, and made snowmen. Another integral part of Shaker recreation was the taking of trips, and before the introduction of the automobile, the Shakers in Canterbury relied upon horses for personal travel, to pull their sleighs in the winter and their buggies throughout the rest of the year. During the early 1900s, the most popular horse at the village was "Major," often pictured with buggies and sleighs.

However, not even their love of horses could equal the Shakers' zeal as they fell instantly and passionately in love with the automobile. While some of their enthusiasm may have stemmed from a love of technology itself, it is more likely that the automobile was prized most because it enabled the Shakers to visit their friends at other Shaker communities more easily, and it increasingly allowed them to peddle their manufactures in resort areas

and on the seacoast. By virtue of communally owned assets, the Canterbury Shakers were among the first people in New Hampshire able to afford motor vehicles, and the purchase of automobiles prompted the Canterbury Shakers to construct their first garage, of pressed metal, in 1908, and then a Steel Garage in 1923.

Most of the photographs of Shaker automobiles were taken by Bertha Lindsay and Irving Greenwood, and Brother Irving was often photographed behind the steering wheel. While many of the automobiles purchased by the Canterbury Shakers have yet to be discovered in photographs, journal accounts indicate that they acquired many models of Marmons, Cadillacs and Buicks, Packard sedans and coupes, Pierce-Arrows, a Stanley Steamer, a Reo touring car, a Reo Speed Wagon, an Atlas touring car, a Stoddard Dayton touring car, a Hudson Sedan, a Hudson Roadster, a Hudson Cab, and—in later years—comparatively inexpensive automobiles such as Dodges and Plymouths. Perhaps most distinctive of all was Canterbury's "Snowmobile," which was occasionally photographed on Shaker Road and running atop the mill ponds.

The Canterbury Shakers did not limit themselves to travel by land, however. They kept a rowboat on one of their small mill ponds, and this was occasionally used in theatrical productions of "Hiawatha." But more significantly, they purchased two large speedboats, which they operated from their camp, "Point Comfort," on Lake Winnisquam. Several photographs of these vessels have survived, typically showing Brother Irving behind the wheel with rows of sisters seated behind him.

After the passing of Irving Greenwood, the Canterbury sisters continued to travel, with the aid of friends, but as the community aged, they spent more of their time at home, entertaining and cooking for visitors, continuing their fancywork, and welcoming the Shaker scholars who increasingly came to visit. The abundance of well-worn books in several Canterbury Shaker libraries also illustrates the fact that the Shakers had time to read.

The Church Family Dwelling House Library, for example, has sections on history, natural history, religion, science, travel, and literature, as well as illustrated books on butterflies, flowers, foreign lands, and other subjects. A generous number of biographies and novels line the shelves, along with extensive runs of *Scientific American*, *Century*, *Life*, and *National Geographic* magazines.

During the final years of the Canterbury community, the sisters enjoyed television and, in addition to family-oriented viewing and religious programming, a favorite show was *Wall Street Week*. As Eldress Gertrude Soule observed, she especially enjoyed its star, Louis Rukeyser, "because he's so handsome." When word of the Shakers' especial fondness for him reached the television host, he responded with a card that quite delighted them. Such anecdotes are not unusual, however. Practically everyone who met the Shakers in Canterbury has similar stories to tell, and it is undeniable that the Shakers knew how to have fun and brought a great deal of enthusiasm to all of their leisure activities.

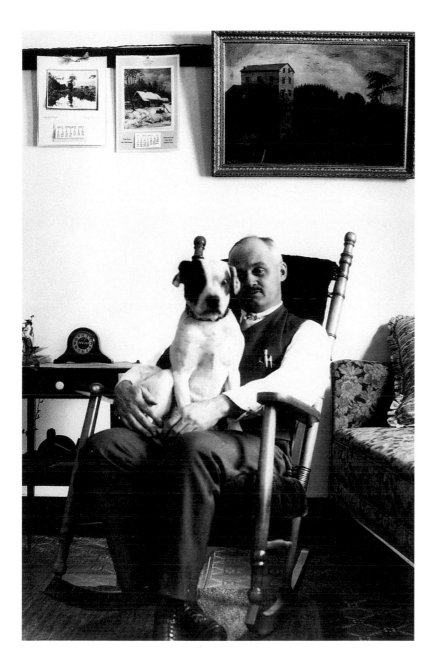

Figure 92 "Irving & Dewey" Brother Irving Greenwood seated in his rocking chair with his dog "Dewey," February 1923. While earlier Shakers had disapproved of pets, by the twentieth century cats and dogs had become extremely popular. [24-P66, 1-PN167]

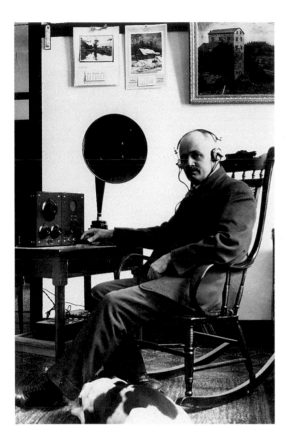

Figure 93 Brother Irving Greenwood purchased a crystal radio in January 1922. The *Historical Record* of the Church Family for that year noted: "Buy a Westinghouse Type R. C. Radio Outfit with a Magnavox Loud Speaker, Storage Battery and Antenna of the Lewis Electrical Supply Co. Boston. Use it the first time Feb. 25th. Cost of Complete Outfit $234.50" (p. 322). In this photograph, Irving Greenwood and "Dewey" are listening to the radio in February 1923. [27-P2, 1-PN168]

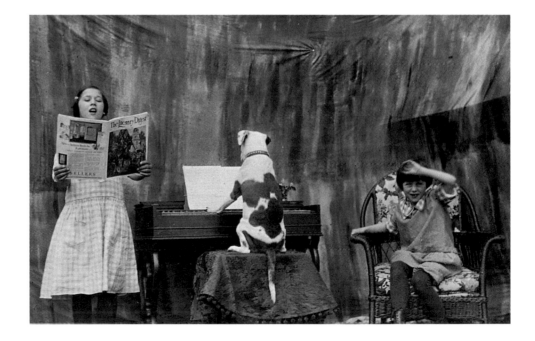

Figure 94 "The First Performance[.] Rosamond[,] 'Dewey[,]' Helen." "Dewey" plays the piano as Rosamond Stark sings for him! [27-P92, P106]

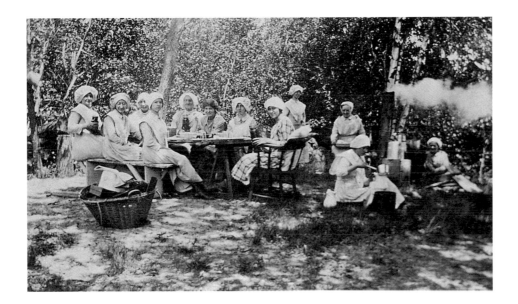

Figure 95 "Picnic at the Pond," ca. 1920. The Canterbury Shakers delighted in picnics, usually held in the woods by Ice Mill Pond, and here is a house-cleaning crew that had just come from cleaning one of the mills. They kept a small wood stove (right) next to the pond, and they also stored a set of dishes in the nearby Ice Mill. [12-P109, 15-P72]

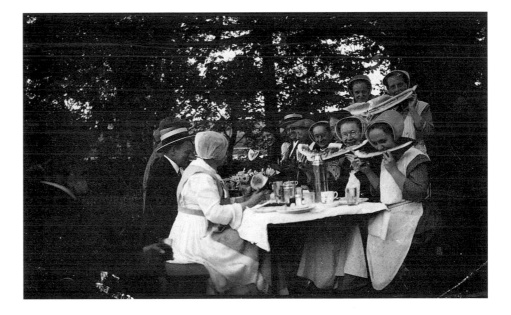

Figure 96 "[P]icnic at Woodmill Pond with the Parkhursts and Murrays." The Canterbury Shakers and some of their friends are having a picnic at Ice Mill Pond, ca. 1924. Brother Irving Greenwood and Sisters Helena Sarle, Lucy Hunt, Ida Crook, and Miriam Wall are in the group. According to Sister Bertha Lindsay, the Canterbury Shakers "always cut their watermelons this way—it's the way they cut watermelons in the South" (personal communication). [24-P124, 1PN84]

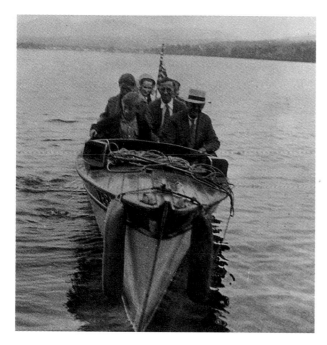

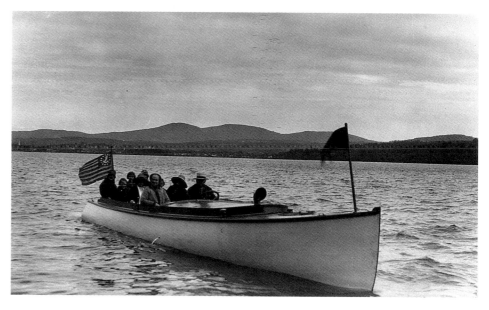

Figure 98 "Point Comfort our Camp on Lake Winnisquam." Brother Irving Greenwood (behind the wheel) and sisters riding on Lake Winnisquam in their second boat, the 32-foot-long *The Arthur*, purchased in 1926. [6-P38, 24-P144, 1-PN378]

Figure 97 "'The Verna' Bought Sept. 23, 1923. Just returning from a trip around the Lake. No one looks frightened do they?" From 1925 to 1938, the Canterbury Church Family owned a summer cottage and two acres of land on Lake Winnisquam in the town of Sanbornton. Here Brother Irving Greenwood (front right), sisters and friends are riding in *The Verna*, the first power boat they operated on Lake Winnisquam. [6-P29, 1-PN388]

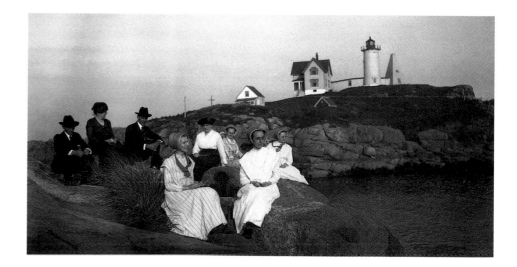

Figure 99 "Trip to the Beach with Mr. and Mrs. Moore from Ohio." The Canterbury Shakers often took trips to the beach, which they believed promoted good health. Here a group of Canterbury Shakers and friends are seated on the rocks in Cape Neddick, Maine, ca. 1923. Nubble Light is in the background. [9-P147, 1-PN273]

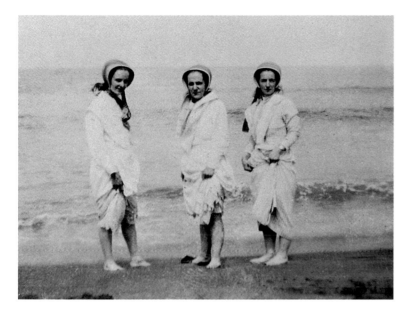

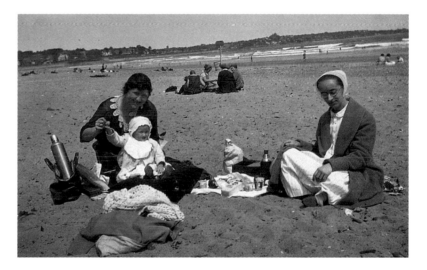

Figure 100 "Frieda, Miriam, Muriel at York Beach, Maine." Sisters Frieda Weeks, Miriam Wall, and Muriel Hewitt wade along the shore at York Beach. Before long, both Muriel Hewitt and Frieda Weeks had left the Shaker community (in 1930 and 1935, respectively), but Miriam Wall stayed and devoted her whole life to the Shakers, sometimes serving as head cook in the Dwelling House kitchen, and becoming the community's Trustee in 1965. [No album no.]

Figure 102 "Billie & Lea." Sister Lucy Hunt (1885–1927) was one of several Canterbury sisters who traveled west to Union Village in Ohio and stayed there for seven years, nursing the elderly Shakers at that community. Here she enjoys a picnic with her sister, Lenora Cronin, who had decided not to become a Shaker and instead married and bore children. [1-PN196]

Figure 101 Canterbury sisters (left) visit the beach in Cape Neddick, Maine, ca. 1923. Their prim Shaker bonnets and uniform attire contrast sharply with the "world's people" who are standing on the right. [1-PN271]

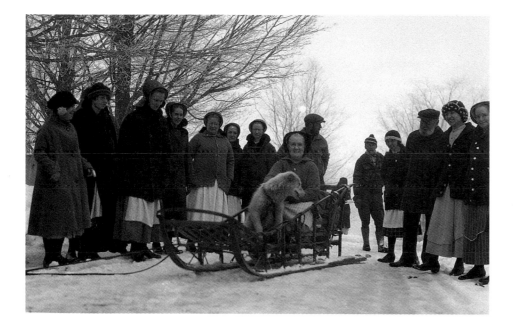

Figure 103 "Sled Dog Races from Laconia 1922." Sled dog teams from Laconia, New Hampshire, visited the Canterbury Shakers in 1922, and here Sister Josephine Wilson poses with one of the sled dogs.

Sister Josephine was born in Lynn, Massachusetts, and entered the Canterbury Society in 1875. In 1918 she became a Trustee and responsible for many of the community's business dealings, and in 1939 she became a member of the Lead Ministry. Together with Sister Sarah Wilson, she ran the cloakmaking industry at the village, producing the "Dorothy" cloaks. [27-P85, 1-PN146]

Figure 104 "[C]oasting party." The Canterbury Shakers enjoyed coasting down Shaker Road in the wintertime, as demonstrated here in front of the Church Family Trustees' Office (left). [11-P20, 12-P61, 1-PN203]

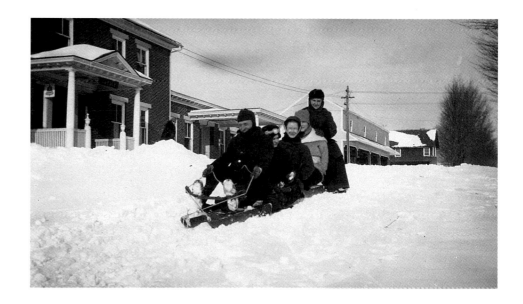

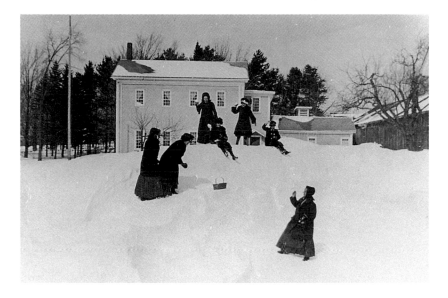

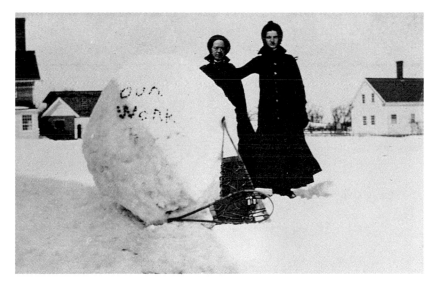

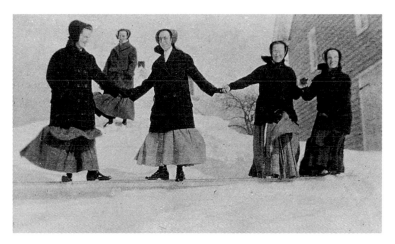

Figure 105 "Winter Snows at Canterbury 1922." "March 7th Snowstorm." After a major snowstorm in 1922, these sisters are clearly enjoying the opportunity to play in the snow in front of the Church Family School House. [13-P64, 15-P39]

Figure 106 After what was probably the same 1922 snowstorm, these sisters have fashioned a giant snowball, which reads "Our Work." [20-P9]

Figure 107 "Winter Snows at Canterbury 1922." Hand-in-hand as they play in the snow, these Canterbury sisters include Lillian Phelps, Harriet Drought, and Florence Phelps. [15-P40]

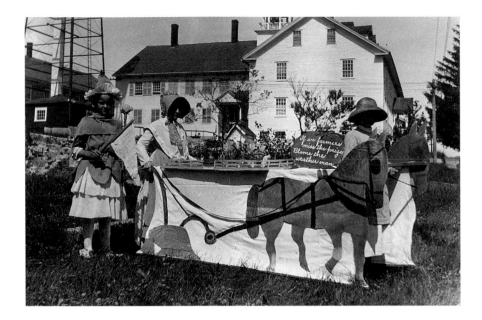

Figure 108 "Parade, 4th of July, 1916" "Garden Float 1916." This float and those that follow were prepared for a July 4th celebration in 1916; however, because of rain, the Shakers did not hold this costume event until July 6. Each float (approximately fourteen all together) represented one of the buildings or trades at Canterbury Shaker Village, and the participants paraded through the Church Family between two and three in the afternoon. The elaborateness of the costumes and floats suggests that a great deal of effort went into preparing this event. The Church Family Dwelling House is in the rear in each of these photographs.

The sign on the side of this float (two horses pulling a plow) reads: "If we farmers miss the prize Blame the weather man." [25-P27, 1-PN160]

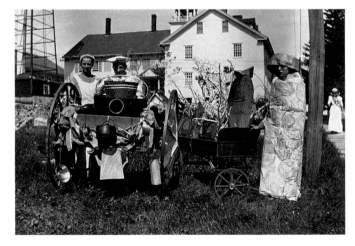

Figure 109 "Parade, 4th of July, 1916" "Kitchen Canning." This entry in the parade on July 6 was another garden float, and the wagons were decorated with pots and pans, potatoes, and apples. (The girl on the right was dressed to look like a canning jar filled with peas.) This float won second prize in the parade. [25-P28, 1-PN161]

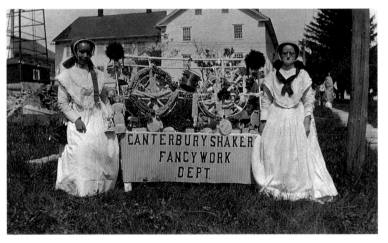

Figure 110 "Parade, 4th of July, 1916." This float representing the "Fancywork Dept." is flanked by Sister Edith Green (left), who often crocheted, and Sister Antoinette Chandler (right), who was in charge of Canterbury's fancywork industry from 1911 to 1943. [25-P30, 1-PN156]

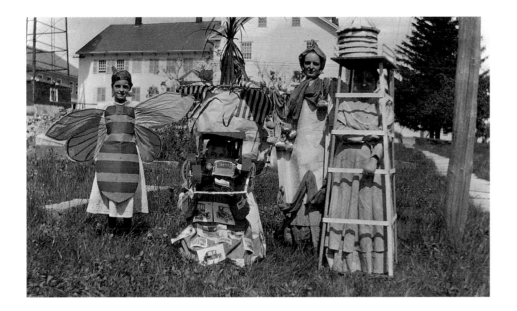

Figure 111 "Parade, 4th of July, 1916." "Bees. Tank." The "tank" on the right represents the Church Family water tower. [25-P32, 1-PN157]

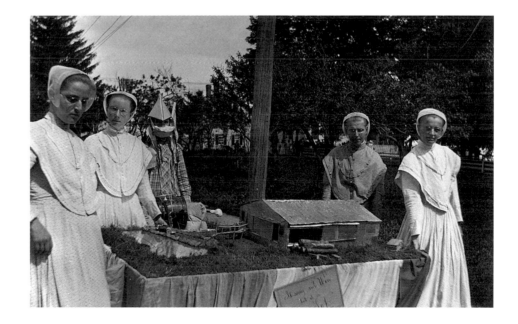

Figure 112 "Parade, 4th of July, 1916" and "Saw mill." This scale model represents (what was then) the new Sawmill, built south of Sawmill Pond in 1915. [25-P33, 1-PN154]

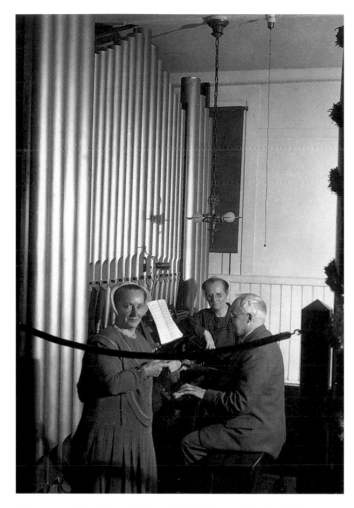

Figure 113 "Pipe Organ. Lillian, Aida, I.G. 1930." Brother Irving Greenwood plays the pipe organ in the Chapel of the Church Family Dwelling House in 1930, flanked by Sisters Lillian Phelps (left) and Aida Elam (right). According to one of the Canterbury journals, in 1929 they "Put the pipe organ in the Meeting Room in Dec. Bought of E. Russel Sanborn. It is dedicated Dec. 31, 1929. It is a Hook and Hastings Organ built in Kendall Green Mass. Nov. 26, 1887. Organ Number 1364. Cost us installed $2000.00." [9-P13, 1-PN135]

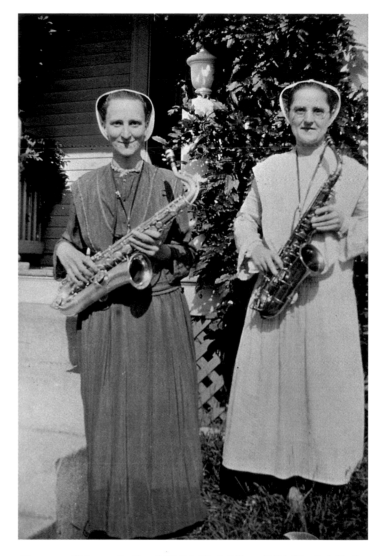

Figure 114 "Marguerite Frost[,] Edith Clark." Sister Edith (Eunice) Clark (right) was born in East Providence, Rhode Island, in 1891 and arrived in Canterbury in 1905. In addition to playing the saxophone, she was a seamstress, assisted with Trustee duties, and helped with sales. She died of cancer in 1957. [10-P53, 11-P249]

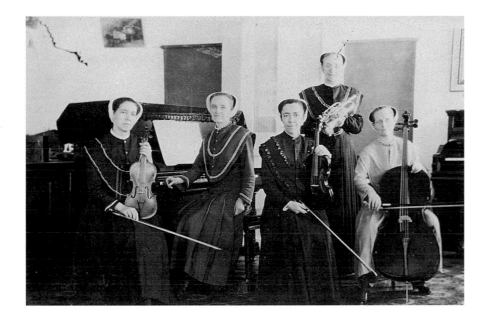

Figure 115 "Orchestra." The Canterbury Shaker orchestra originally consisted of two violins, a cornet, a bass-viol and a piano. Later, another orchestra was formed, composed of two violins, a cornet, a cello, two saxophones, drums, cymbals, a pipe-organ, and a piano. The orchestras typically performed concerts on special occasions, including Easter and Christmas. [11-P167]

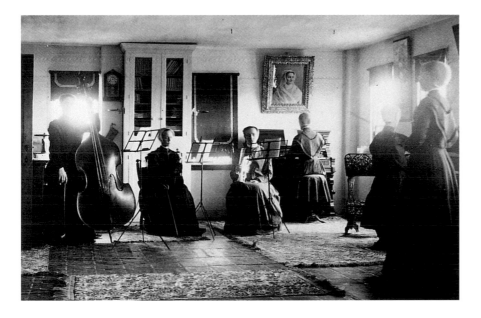

Figure 116 "Josephine Wilson[,] Jessie Evans[,] Helena Sarle[,] Emma King[,] Lillian Phelps[,] Mary Wilson." A Canterbury Shaker orchestra performing inside the East Room of the Church Family Sisters' Shop. [Album 46]

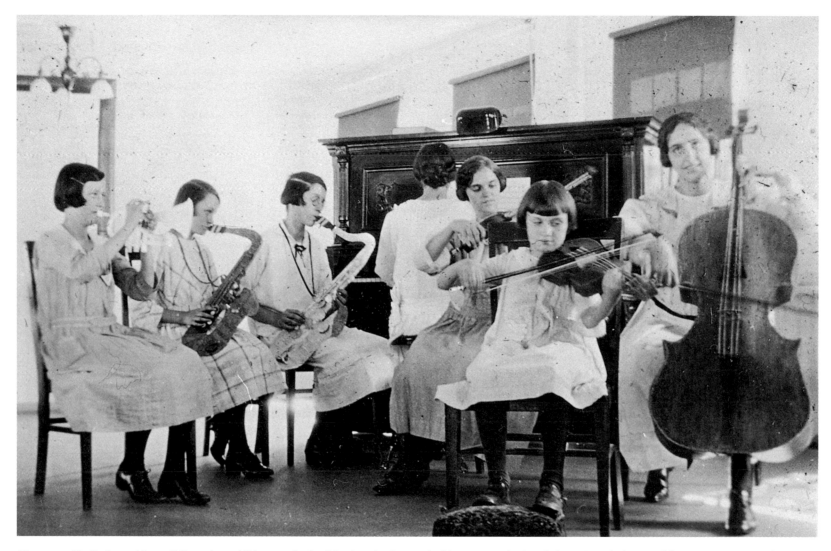

Figure 117 "Jr. Orchestra[,] 1930." Canterbury children received a rich education in music, both in songs and instruments, and they formed trios, quartets, sextets, and double-quartets, sharing their music with the rest of the community. Here the "Junior Orchestra" is performing in 1930. [10-P54, 20-P127]

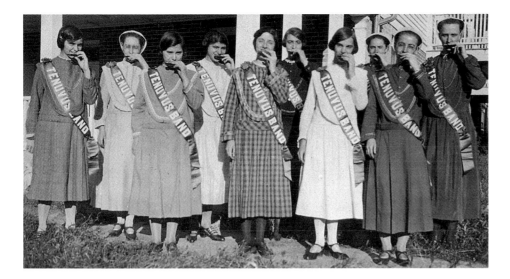

Figure 118 The "TENUVUS" band, a ten-piece Canterbury Shaker harmonica band. They included Sisters Bertha Lindsay (second from left), Lucy Hunt (second from right), and Marguerite Frost (far right), ca. 1929. [10-P44, 11-P254]

Figure 119 "The Qui Vive Trio—Lillian, Helena, Jessie." A Shaker Ladies Quartet, the "Qui Vive Quartet," was directed by Elder Arthur Bruce, and their public performances were much in demand for over twenty-five years. According to Sister Bertha Lindsay, "Elder Arthur was very devoted to music, and he taught the Sisters to sing." The quartet consisted of Sisters Helena Sarle, Jennie Fish, Josephine Wilson, and Jesse Evans; they performed without accompaniment and could sing over 100 selections from memory. This smaller "Trio" contains two members of the quartet, Sisters Jessie Evans (left) and Helena Sarle (right), together with Sister Lillian Phelps (center). [1-PN255]

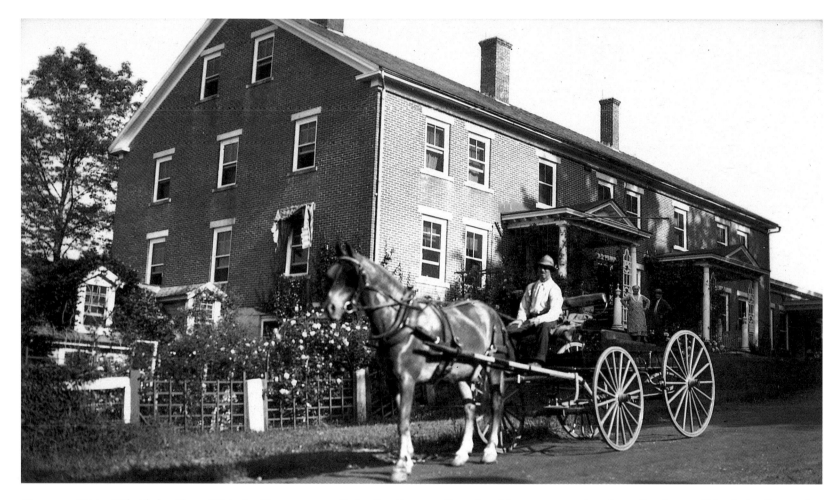

Figure 120 "Major." The Shakers' horse "Major" pulling a wagon on Shaker Road in front of the Church Family Trustees' Office. Many years later, Sister Bertha Lindsay would reminisce: "I can remember as a little girl dragging the very sweet horse, 'Major,' up here [to the Upper North Family orchard] to gather the apples with Sister Rebecca."

Canterbury's horses were consistently excellent because Elder Arthur Bruce, who was especially fond of fast horses, visited local race tracks and bought the best horses he could. However, while work horses continued to be used for some tasks, automobiles quickly replaced horses as the Shakers' preferred mode of transportation. [1-PN506]

Figure 121 "The Reo." This Reo Touring Car was the first car purchased by the Canterbury Shakers, for $1400, on May 2, 1907. Brother Irving Greenwood is behind the wheel, with the Church Family Power House in the background. This photograph was taken in 1910, the year that the Power House was constructed; that same year, the "Reo" was sold by the village for $480. [31-P52, 4-PN70]

Figure 122 "Irving Greenwood and the 'Atlas.'" Canterbury Shaker Village purchased this Atlas touring car in September of 1908 for $2750. Brother Irving Greenwood is behind the wheel. [Album 38]

Figure 123 "Elder Arthur and Irving in Buick at Newmarket, N.H." "1914." The Canterbury Shakers owned two Buicks in 1914 and 1915: a "Model 30" purchased for $1125, and a "Model 36" purchased for $550 (the first automobile was used as a trade-in for the second). [Album 38, Album 39]

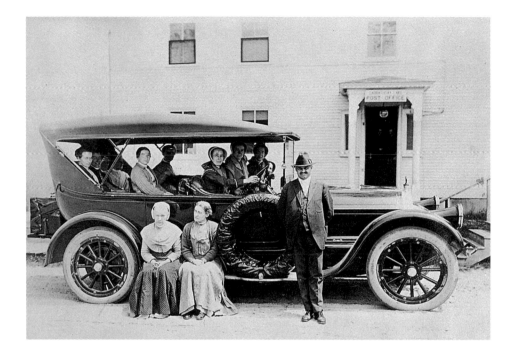

Figure 124 Brother Irving Greenwood and a group of Canterbury sisters posed with their 1917 Pierce-Arrow Touring Car, purchased for $5000, in front of the Shaker post office in Sabbathday Lake, Maine, ca. 1917–1919. Irving Greenwood or one of the hired men always drove the community's automobiles and trucks, so it is doubtful that this scene actually shows a sister driving. However, during her final years, Eldress Gertrude Soule enjoyed telling the story of how she once was "pulled over" in Maine for speeding. [14-P37]

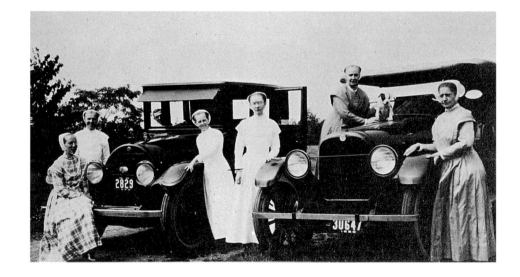

Figure 125 "Groups of Canterbury Sisters with Friends." The "Friends" are clearly their automobiles, and the year "1920" appears on the license plate of each automobile. [13-P22, 20-P27, 3-PN91]

Figure 126 "Alta and the Marmon." The Canterbury Shakers purchased a "74" Marmon in 1925, a "75" Marmon in 1926, and a Marmon Coupe in 1928, all of which were much less expensive than the Pierce-Arrows and Cadillacs they had previously purchased. Here one of the Marmons appears on Shaker Road in front of the Church Family Trustees' Office. [1-PN509]

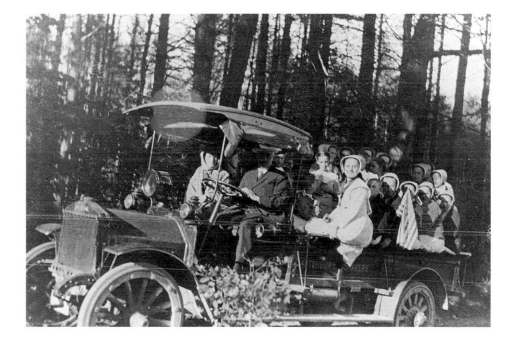

Figure 127 "On way to Lake Winnesquam. 1924." Brother Irving Greenwood transporting a large group of sisters to nearby Lake Winnisquam in the "Federal" truck. Just a year later, in 1925, the Canterbury Shakers purchased a camp on Lake Winnisquam, which they named "Point Comfort." [PN11]

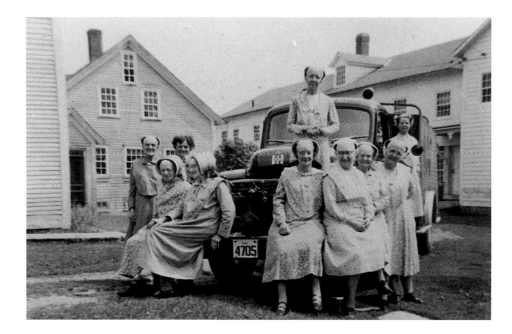

Figure 128 "Eldress Emma King, Sister Flora Appleton, Sister Lillian Phelps, Sister Bertha Lindsay, Sister Aida Elam, Sister Miriam Wall, Sister Ethel Hudson, standing—Alice Howland." Canterbury sisters seated on the front of their International Harvester truck (owned by the community between 1928 and 1935). [9-P94]

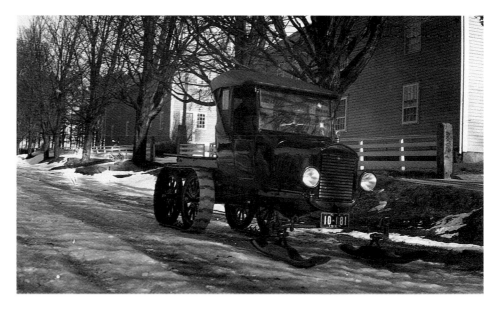

Figure 129 The Canterbury Snowmobile on Shaker Road in front of the Church Family Infirmary in the spring of 1924. Purchased in July of 1923 for $790, the vehicle had large skies on the front and caterpillar treads on the rear. [1-PN42]

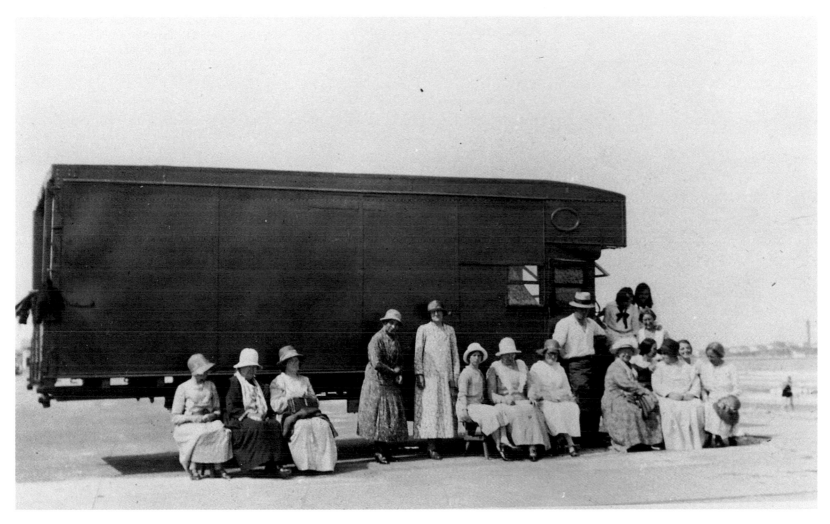

Figure 130 "At Hampton Beach, 1933." The Canterbury Shakers, in very uncharacteristic clothing, visiting Hampton Beach, New Hampshire, in 1933. Among those present are Sisters Edith Green, Ethel Hudson and Bertha Lindsay. [14-P88, PN216]

Entertainments

✳ Although the restrictions of Shaker belief and communal practice appear harsh in terms of contemporary, individualistic, American life, there nevertheless was a powerful current of celebration that flowed through Shaker ritual. And while religious worship was the main goal, song and dance in group worship were also recreational in the physical and social senses. The Canterbury Shakers stopped dancing in worship about 1900, but recreational dancing continued well into the twentieth century. Furthermore, with the introduction of musical instruments into the community in the 1870s, worship and recreation changed. Groups of singers and instrumentalists formed for religious and social purposes, and gave performances for the Canterbury Shakers and for other religious and community organizations. The children also had special music ensembles, and the adult music groups traveled extensively, providing special music for religious services and Old Home celebrations.

One of the most active and interesting of the group recreations of the Canterbury Shakers was their "entertainments." The outside world might have called them dramas, skits, or plays, but the Shaker word "entertainments" marked these activities as having a particular Shaker slant. Shaker entertainments entered community life in the late 1870s, and as with earlier activities, these entertainments served group purposes. The content was at times of less importance than the process of writing, staging, and performing. Tremendous amounts of time must have been consumed in these activities, but they were wholesome outlets for creative expression, and everyone could participate at some level.

Some of the entertainments were partly or wholly original, but the majority were borrowed or adapted from a vast body of non-Shaker literature available from the 1880s through the 1920s. This genre of literature was created for the rapidly expanding Protestant Sunday School movement and for public schools that used pageants to promote patriotism and to demonstrate student achievement.

Shaker entertainments were religious and secular, serious and comedic, dramatic and musical. Although generally following the traditions of late-nineteenth-century American society, the Shakers carefully screened their selections and occasionally edited dialogue in order to avoid offense to their fellow Shakers. Hundreds of these booklets survive at Canterbury, often with marginal notations with initials or names of the Shaker players, and revised texts.

The primary initiative for the entertainments came from within the Shaker community. By 1893 Church Family records were regularly recording the entertainments. They reflect the sense of anticipation generated by months of preparation, and the satisfaction derived from participation in a significant community event. The earliest pageants were religious and philosophical, generally extensions of religious holiday celebrations. As time progressed, the programs developed to embrace a wider range of topics, to include more of the Shaker community, especially children, and to reach a larger audience.

The Shaker Ministry was deeply involved in the planning and execution of the entertainments. Their involvement probably began before they became eldresses, but Jesse Evans, Josephine Wilson, Emma King, Lillian Phelps, Marguerite Frost, and Bertha Lindsay all participated in the pageantry, whether religious or secular. For more than forty years the entertainments were central to the social life of the Canterbury Shakers. The entertainments declined in number during the 1930s and ended about 1936.

Their cessation, the death of the last Shaker brother in 1939, and the decision not to admit new children into the community, all occurred in this same period of time, marking with finality and clarity the end of an era in the history of Shaker communalism.

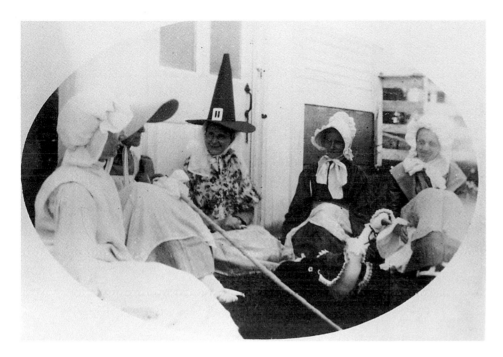

Figure 131 "Mother Goose & her children." This "Mother Goose" party was probably held just after the Independence Day parade on July 6, 1916. [11-P183, 25-P36]

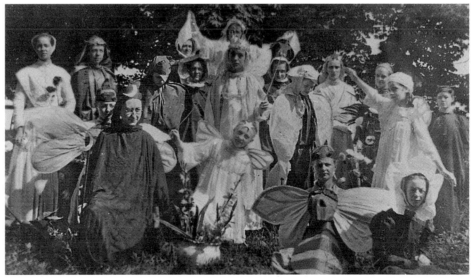

Figure 132 "Pantomine of one of the entertainment selections on July 4th. The entertainment was held indoors, but the picture was taken in the lane by the Old Church." Sister Bertha Lindsay is seated in the left foreground. [25-P69, PN8]

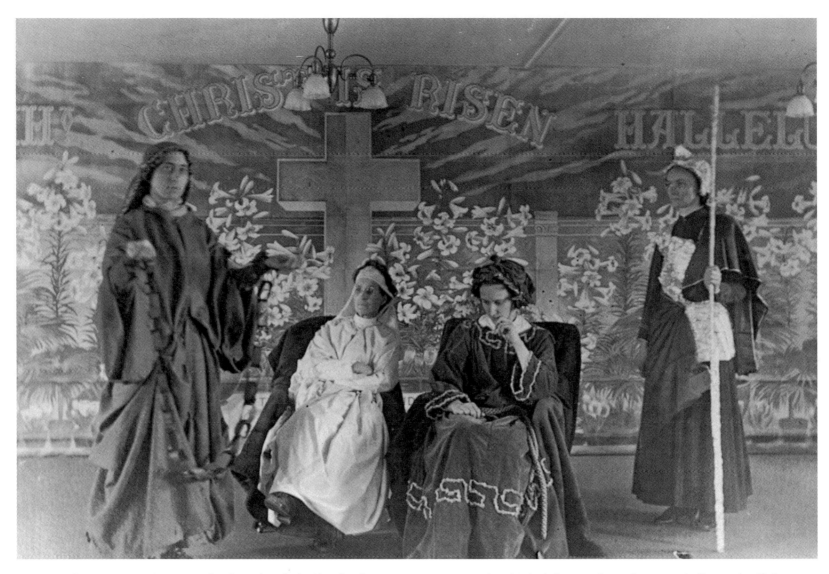

Figure 133 "Entertainment given in 1919 [performed inside the Chapel in the Church Family Dwelling House]. 'Sacrifice.' Abraham[,] Sarah and Chorus." Enter- tainments such as this, both drama and comedy, were typically staged at Christmas, Easter, and midsummer. [10-P28]

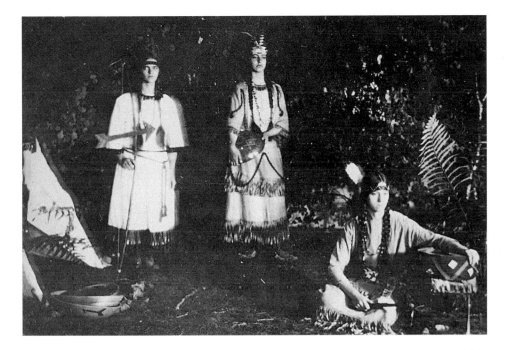

Figure 134 "Entertainment Pictures." "An Indian Entertainment." Probably 1926. Girls dressed as Indian maidens are performing in "Hiawatha" inside the Church Family Meeting House; a teepee stands at left. The ferns in the entertainment were later taken outside and replanted around the Meeting House. [15-P59, 20-P105]

Figure 135 "Entertainment Pictures." Probably 1926. An Indian maiden from "Hiawatha" stands in the Canterbury rowboat, probably on one of the mill ponds. [15-P60]

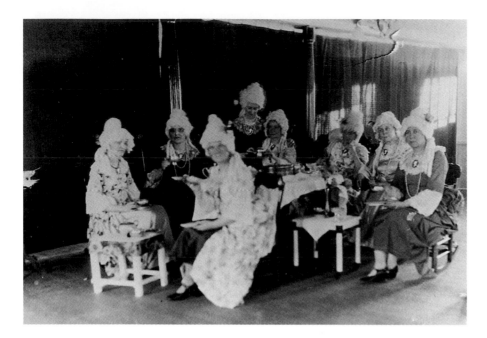

Figure 136 "Dorothy Vernon's Soiree. By the Spiritoso Orchestra [performing inside the Chapel in the Dwelling House]. Feb. 22, 1928." The Spiritoso Orchestra was organized in 1926 and was composed of Sisters Helena Sarle, Evelyn Polsey, Marguerite Frost, Edith Clark, Aida Elam, Ida Crook, and Alice Howland. [10-P2, 2-PN247]

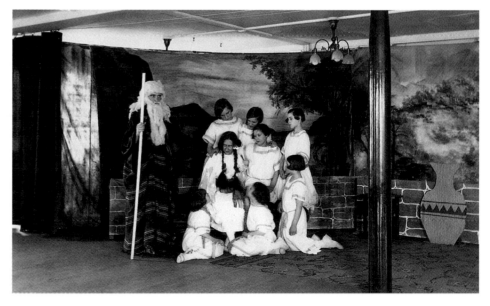

Figure 137 "A Dream of Queen Esther. A Biblical Drama In Three Acts. Rendered Easter 1929." This Entertainment featured Jewish figures from Biblical history, including "Mordicai," Esther, Jewish heroines, Persian maids, and others. They performed inside the Chapel. [10-P5, 2-PN292]

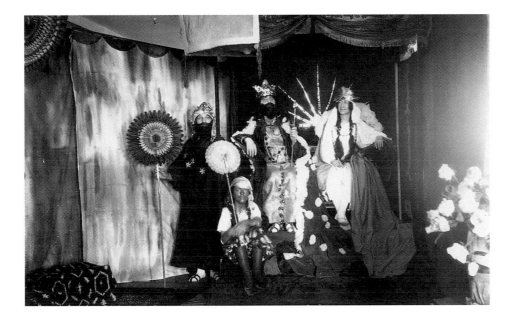

Figure 138 "A Dream of Queen Esther. . . . Easter 1929." [10-P14, 2-PN305]

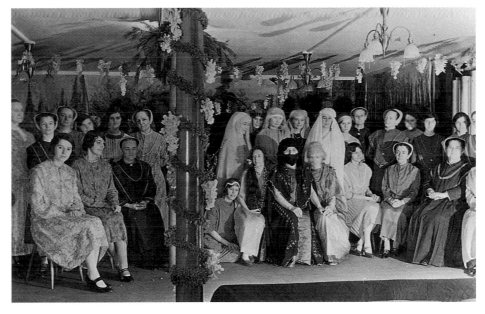

Figure 139 "Judith." This Biblical Entertainment, performed inside the Chapel during Easter, 1930, was set in the Garden of Joseph of Arimathea and featured Joseph, his daughter Judith, Mary "Magdaline," the Angel Gabriel, and others. [10-P25, 2-PN282]

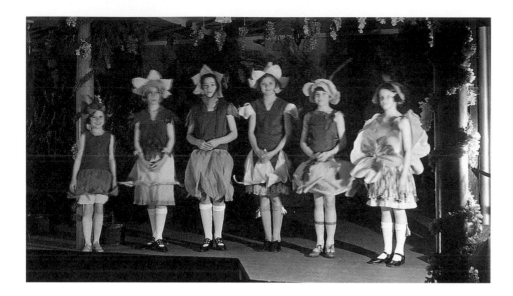

Figure 140 "Judith." 1930 [10-P26, 2-PN285]

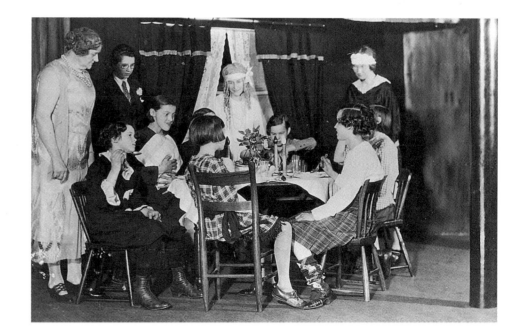

Figure 141 "From Birds' Christmas Carol. The 'Ruggles Family.' Helen—Beatrice—Bertha—Laura." The "Birds' Christmas Carol," which the Shakers ascribed to Charles Dickens, was performed as an Entertainment in the Chapel on Dec. 25, 1930. [10-P36, P275, P276, 2-PN255]

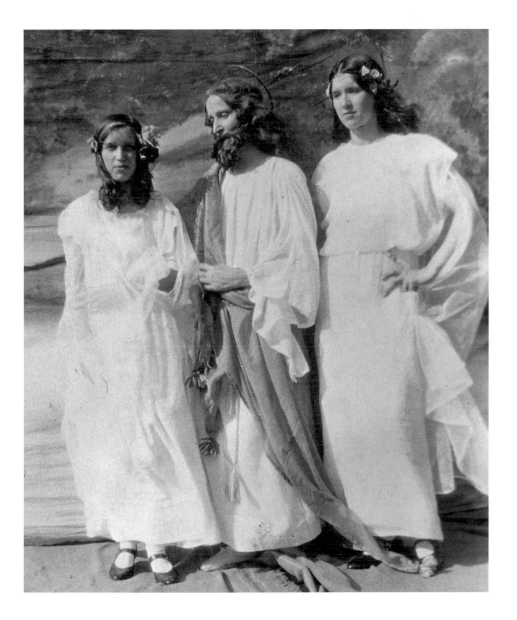

Figure 142 "Easter 1932." A Shaker religious pageant performed on Easter 1932, with Sister Marguerite Frost (center) dressed as Jesus. [10-P39]

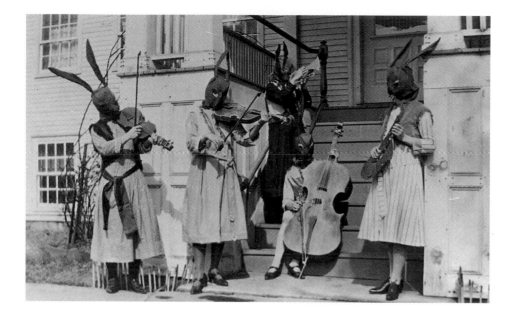

Figure 143 "Easter 1932." Canterbury sisters (or perhaps girls), wearing rabbit masks, are playing musical instruments on the steps of the Church Family Dwelling House. [10-P42]

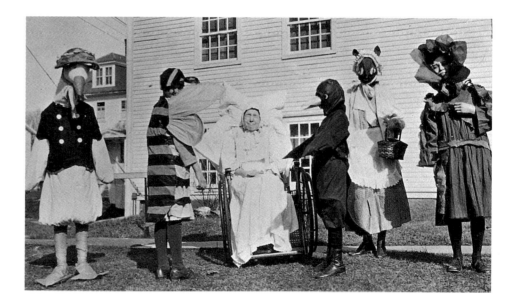

Figure 144 "Easter 1932." Canterbury sisters (or girls) wearing animal costumes outside the Church Family Dwelling House. [10-P41]

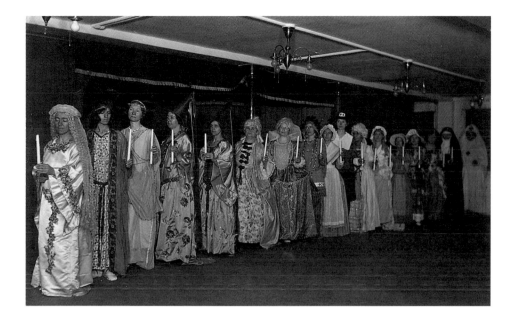

Figure 145 "Entertainment" inside the Chapel in the Church Family Dwelling House. [2-PN280]

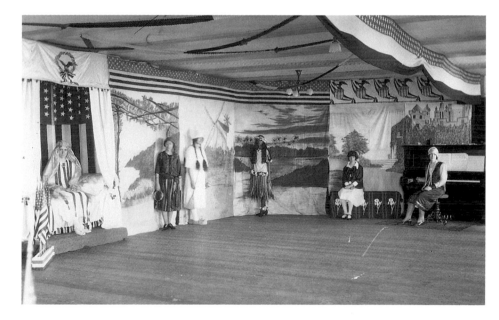

Figure 146 "Entertainment" inside the Church Family Meeting House. The Canterbury Shakers made their own backdrops and sets, and many of these—as seen here—were painted by Sister Helena Sarle. [2-PN283]

Figure 147 "The 'Never Ready's.'" Sister Bertha Lindsay is standing at far left. [No album no.]

Figure 148 Girls performing in a May Day dance. According to Sister Bertha Lindsay, in April they would all go out to rake the lawns and then would have a Maypole dance on the first day of May. [25-P68]

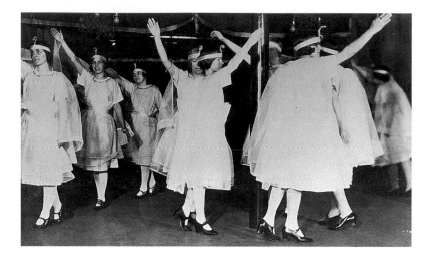

Figure 149 "From Mid-Summer's Night Dream." Girls, in costume, are performing inside the Chapel in the Church Family Dwelling House. [10-P45, 2-PN254]

Figure 150 "Hazel & Gertrude." Hazel Smith and Gertrude Roberts, possibly in outfits designed for "Snowbound" by Whittier, pose on the steps of the Dwelling House. Sister Gertrude Roberts was one of the more avid Canterbury photographers, but after working in the Dwelling House kitchen and in the fancywork business, she subsequently left the village in 1935. [10-P47, 2-PN265]

RECOMMENDED READING

The Shaker Movement

Until now, only one book has systematically used photographs to reveal aspects of daily life among the Shakers, and that is the very popular *The Shaker Image* by Elmer R. Pearson and Julia Neal (Boston: New York Graphic Society, 1974). However, this very important volume is a potpourri of photographs from all of the Shaker societies, with fewer than twenty images from Canterbury.

There also are a vast number of books and articles that summarize Shaker life, manufactures, religion, and architecture, drawing upon all of the Shaker villages. Some of the better examples are:

Andrews, Edward Deming. *The Community Industries of the Shakers*. New York State Museum Handbook, no. 15. Albany: University of the State of New York, 1932.

————. *The People Called Shakers. A Search for the Perfect Society*. New York: Dover Publications, 1953, 1963.

Brewer, Priscilla. *Shaker Communities, Shaker Lives*. Hanover: University Press of New England, 1986.

Burns, Amy Stechler, and Ken Burns. *The Shakers Hands to Work Hearts to God*. New York: Portland House, 1987.

Emlen, Robert P. *Shaker Village Views: Illustrated Maps and Landscape Drawings by Shaker Artists of the Nineteenth Century*. Hanover: University Press of New England, 1987.

Grant, Jerry V., and Douglas R. Allen. *Shaker Furniture Makers*. Hanover: University Press of New England, 1989.

Marini, Stephen A. *Radical Sects of Revolutionary New England*. Cambridge, Mass.: Harvard University Press, 1982.

Melcher, Marguerite Fellows. *The Shaker Adventure*. Old Chatham, N.Y.: The Shaker Museum, 1975.

Nicoletta, Julie. *The Architecture of the Shakers*. Woodstock, Vermont: The Countryman Press, 1995.

Poppeliers, John, ed. *Shaker Built: A Catalog of Shaker Architectural Records from the Historic American Buildings Survey*. Washington, D.C.: HABS, National Park Service, U.S. Department of the Interior, 1974.

Rieman, Timothy D., and Jean M. Burks. *The Complete Book of Shaker Furniture*. New York, N.Y.: Harry N. Abrams, Inc., 1993.

Sprigg, June. *By Shaker Hands*. Hanover, N.H.: University Press of New England, 1990.

————. *Shaker Design*. New York and London: Whitney Museum of American Art in Association with W. W. Norton Company, 1986.

The Canterbury Shakers

PRIMARY SOURCES
The archives of Canterbury Shaker Village contain many journals and diaries written by the Shakers that are extremely helpful in understanding life from a Shaker perspective. Among the best of these are:

Blinn, Elder Henry C. "Church Record." Canterbury, N.H., 1784–1879, 312 pp., handwritten.
————. "A Historical Record of the Society of Believers in Canterbury, N.H. From the time of its organization in 1792 till the year one thousand, eight hundred and forty eight." Canterbury, N.H., 312 pp., handwritten, indexed.
Greenwood, Brother Irving. "Daily Reminder 1936." Canterbury, N.H.
————. "Notebook of information on machinery, buildings, equipment, property, etc." Canterbury, N.H., n.d., 288 pp., handwritten.
"Historical Record of the Church Family East Canterbury, N.H. Compiled by the Brethren for special reference. 1890–1930." Canterbury, N.H., 401 pp., handwritten.
Whitcher, Brother John, et al. "A Brief History or Record of the Commencement & Progress; of the United Society of Believers, at Canterbury. County of Merrimack. And. State of New Hampshire. By John Whitcher, A Member of Said Society." Canterbury, N.H., Vol. 1, 1782–1871, 366 pp., handwritten.
Winkley, Brother Francis, et al. Journal. Canterbury, N.H., 1784–1845, 114 pp., handwritten.

SECONDARY SOURCES
It is impossible to list all of the available secondary sources that cover the history of the Shaker experience in Canterbury. However, some of the more useful publications are:

Borges, Richard C. "The Canterbury Shakers: A Demographic Study." Unpublished Ph.D. dissertation, Dept. of History, University of New Hampshire, Durham, 1988.
————. "The Canterbury Shakers: A Demographic Study." *Historical New Hampshire* 48, 2 & 3 (Summer/Fall 1993), pp. 155-81.
Boswell, Mary Rose. "Women's Work: The Canterbury Shakers' Fancywork Industry." *Historical New Hampshire* 48, 2 & 3 (Summer/Fall 1993), pp. 133-54.

Burks, Jean M. *Documented Furniture: An Introduction to the Collections.* Canterbury, N.H.: Shaker Village, Inc., 1989.

Cliver, E. Blaine. *The Carpentry Shop: An Historic Structure Report.* Canterbury, N.H.: Shaker Village, Inc., 1989.

Emerson, Martha Mae. "The Shakers' Largest Wooden Barn." *New Hampshire Profiles* 23 (1974), pp. 50-53.

Kay, Jane Holtz. "Last of the Shakers." *Historic Preservation* 34, 2 (March/April 1982), pp. 14–21.

Lindsay, Eldress Bertha. *Seasoned with Grace.* Woodstock, Vermont: The Countryman Press, 1987.

Lyford, James Otis. *History of the Town of Canterbury, New Hampshire, 1727–1912.* Concord, N.H.: The Rumford Press, 1912; Canterbury, N.H.: Canterbury Historical Society, 1973.

Starbuck, David R. "Canterbury Shaker Village: Archeology and Landscape." *The New Hampshire Archeologist* 31, 1 (1990), pp. 1–163.

———. "Documenting the Canterbury Shakers." *Historical New Hampshire* 43, 1 (1988), pp. 1–20.

———. "The Shaker Mills in Canterbury, New Hampshire." *IA, The Journal of the Society for Industrial Archeology* 12, 1 (1986), pp. 11–38.

———. "Those Ingenious Shakers!" *Archaeology Magazine* 43, 4 (1990), pp. 40–47.

Swank, Scott T., and Sheryl N. Hack. "'All we do is build': Community Building at Canterbury Shaker Village, 1792–1939." *Historical New Hampshire* 48, 2 & 3 (Summer/Fall 1993), pp. 99–131.

Walsh, Donald. "The Canterbury Shakers: A Case Study of Shaker History, Ingenuity, and Determination." Unpublished B.A. thesis, Iona College, 1976.

UNIVERSITY PRESS OF NEW ENGLAND publishes books under its own imprint and is the publisher for Brandeis University Press, Dartmouth College, Middlebury College Press, University of New Hampshire, Tufts University, and Wesleyan University Press.

LIBRARY OF CONGRESS CATALOGING-IN-PUBLICATION DATA

Starbuck, David R.
 A Shaker family album : photographs from the collection of Canterbury Shaker Village / by David R. Starbuck and Scott T. Swank.
 p. cm.
 Includes bibliographical references.
 ISBN 0–87451–847–4 (pbk.)
 1. Shakers—New Hampshire—Canterbury—Pictorial works.
 I. Swank, Scott T. II. Shaker Village, Inc. III. Title.
 BX9768.C3S73 1998 97–29642
 289'.8'0974272—DC21